IMAGES
of America

POUDRE CANYON

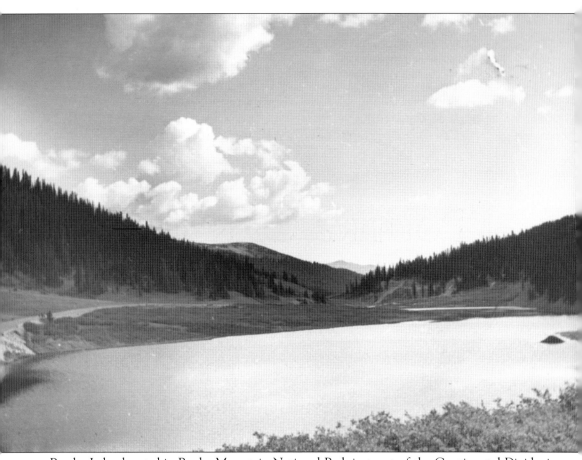

Poudre Lake, located in Rocky Mountain National Park just east of the Continental Divide, is the headwaters of the Poudre River. The river travels 126 miles from its alpine start to its junction with the South Platte River, five miles east of Greeley, Colorado. During the trip, the Poudre River tumbles from 10,755 feet where it begins to 4,600 feet where it enters the South Platte River, cutting the Poudre Canyon in the process. (FCLHA Ha2940.)

ON THE COVER: For some, the mining process could be simple. Here, Albert Case brings ore up from his gold mine, probably in the Manhattan Mining District. Albert Case was the great-grandfather of Stanley R. Case, who wrote *The Poudre: A Photo History* in 1995. (FCLHA H08616.)

IMAGES of America

POUDRE CANYON

Barbara Fleming and Malcolm McNeill

Copyright © 2015 by Barbara Fleming and Malcolm McNeill
ISBN 978-1-4671-3370-8

Published by Arcadia Publishing
Charleston, South Carolina

Printed in the United States of America

Library of Congress Control Number: 2015941074

For all general information, please contact Arcadia Publishing:
Telephone 843-853-2070
Fax 843-853-0044
E-mail sales@arcadiapublishing.com
For customer service and orders:
Toll-Free 1-888-313-2665

Visit us on the Internet at www.arcadiapublishing.com

We dedicate this book to the collectors and preservers of history who make research for books like this possible.

Contents

Acknowledgments		6
Introduction		7
1.	The Early History	9
2.	Early Roads	23
3.	The Miners	43
4.	Building the Poudre Canyon Road	57
5.	From Ted's Place to Mishawaka	67
6.	Mishawaka to Rustic	79
7.	Rustic to Kinikinik	95
8.	Kinikinik to Cameron Pass	105
9.	North and South Forks of the Poudre	117

Acknowledgments

We thank Lesley Struc, Fort Collins Local History Archive archivist, for her invaluable assistance with this project. We appreciated the assistance of Jayne Hansen as well. Thanks also go to Rene Lee of the Livermore Woman's Club, Wayne Sundberg, Sue Struthers, and Larry Fullenkamp of the US Forest Service, Colorado State University archivist Vicky Lopez Terrill and History of Colorado, all of whom provided photographs for this book. Our gratitude to Dale Hein, Ben Alexander, and Laurie D'Aubney for informative details.

To write this book we referenced *Among These Hills*, by the Livermore Woman's Club, *Walking into Colorado's Past* by Ben Fogelberg and Steve Grimstead, *History of Larimer County* by Ansel Watrous, *Cache la Poudre: The River as Seen from 1889–1954* by Norman Fry, and *Cache la Poudre, the Natural History of a Rocky Mountain River* by Mary Evans and Howard Evans, along with numerous articles from local newspapers listed in the Colorado Historic Newspapers online digitization project, but our main resource, without which we could not have completed this book, was *The Poudre Canyon, A Photo History*, by Stanley Case. We thank him for his work and his years of being such a significant part of the canyon's story.

Photographs courtesy of the US Forest Service are acknowledged with the initials USFS; those from the Fort Collins Local History Archive with the designation FCLHA followed by a catalogue number, and those from Malcolm McNeill's private collection with the initials MEM. All others are attributed by name.

INTRODUCTION

People who live in Fort Collins, Colorado, have a particular fondness for the canyon to the west of town. Its history is lively and rich, and its roads and trails are resources for hours—days—of recreation among its beauties. Poudre Canyon (as it is known to locals), carved by the Cache la Poudre River eons ago, has many stories to tell.

This book takes the reader on a journey westward on Colorado Highway 14—a highway that was once an almost impenetrable part of the western wilderness—which now makes its way easily through the jagged rocks and steep hills. Stops along the road, as the highway wends its scenic way beside the river, reveal the canyon's past.

We begin before settlement tamed the canyon, at a time when trappers roamed freely among the foliage and along the wild, rushing river, a time when the canyon was part of Native Americans' hunting and camping grounds, a time when only occasional explorers ventured into its thicketed forests, a time before significant human influence on the land. We introduce the reader to colorful individuals who roamed the canyon before settlers began to come.

We learn how the river acquired its name. Decades before the town, Fort Collins, came into being, and Laporte before then, the canyon was inhabited, well known to varieties of individuals, and treasured for its bounty as well as its rugged beauty. It was also, we may suppose, well respected for its dangers.

Young Antoine Janis came to the Cache la Poudre Valley in 1836 with his father, a trapper. Janis was so struck by the beauty of the area that he determined to come back as a grown man, and he did, becoming the first settler in the valley. By the time Antoine and his bride, Elk Woman, settled there 20 years later, the fur trade was all but gone, beaver hats having gone out of fashion and beavers in short supply. Janis and his family survived by hunting, trapping other animals for fur, and keeping the peace with the Native Americans with whom he often interacted. He became multilingual, a skill that served him most of his life.

John Charles Fremont attempted to explore the canyon in 1843, when he was seeking the headwaters of the Platte River. After several futile attempts to make their way up through the formidable canyon, with its sharply steep rock walls, rushing waters, and abundant foliage, the party turned around and left.

Not too long after Fremont's failed expedition, others managed to penetrate the canyon's depths and scale its heights. Tie hacking—cutting logs for railroad ties as railroad lines inched westward—proved prosperous. As the lumber industry became lucrative and thrived, several enterprising individuals built roads to access the trees. One road, built by Jacob Flowers, who founded Bellvue, Colorado, went through the upper canyon toward Walden, Colorado. Hikers and trail bicyclists still use this old trail.

We take the reader along as the first roads are constructed to make traveling the canyon easier, with some detours at historic spots along the way. The reader is invited to visit old mining towns, ride along on a toll road, and stop in at some old hotels. During this time, as access to the canyon

improved, settlement and industry began to grow. It would be into the new century, however, before the road finally went from one end of the canyon to the other. The very impediments that stopped Fremont remained equally impenetrable until the second decade of the 20th century. The canyon had to be entered either from the west, through the areas where mining and tie hacking took hold, or from the northeast, through Livermore, a lively Western town in its time and still an area inhabited by ranchers and other residents.

Now that travelers can go all the way up and down the canyon, we invite readers to join us through this book for a historical tour, as we tell the stories that made the canyon what it is today. The trip starts west from Ted's Place, a landmark at the intersection of Highway 14 and US 287, to Mishawaka, once a resort and now a locally famous and favorite music venue, from there, past Pingree Park Road to Rustic, a former resort and restaurant, and from there to Cameron Pass at the top of the canyon. With a few side trips, we invite the reader to learn more about the area beyond the canyon itself. We visit mining camps and see how railroad ties were harvested.

During the journey back in time, the reader will visit former Civilian Conservation Corps (CCC) camps, present and former resorts, campgrounds, and other landmarks, see how the road was finally joined from end to end, and meet a cast of characters who live on through stories of their adventures, trials, and triumphs.

Roosevelt National Forest encompasses the upper canyon, as it has since 1897, when the forest was part of the Medicine Bow Forest Reserve, becoming the Colorado National Forest in 1910 and renamed in 1932 for Theodore Roosevelt. The Poudre is a national wild and scenic river, the only one so designated in Colorado, and Highway 14 is a national scenic byway, one of 150 in the United States. The lower canyon and the river's path into the South Platte River are designated a National Heritage Site.

Today, the banks of the Poudre River are often lined with fishermen. In winter, cross-country skis and snowshoes leave tracks in the snow. In the spring, rafters enjoy the rapids, created by snowmelt from the high peaks beyond, and in summer and fall, hikers drawn by the multifaceted rocks and forested hills like to explore the many trails, which are host to a wide variety of wildlife. With luck, travelers might see deer, bighorn sheep, rabbits, foxes, elk, coyotes, mountain goats, and a wide spectrum of bird life, from birds of prey to waterfowl, depending on the time of year and the time of day.

Campers fill the campgrounds along the road. The river flows as it has for time unknown, its waters attracting a wide variety of vacationers, music-lovers, sportsmen, and picnickers. Two centuries ago, as humans trod along its banks, the river lured trappers, hunters, and explorers into the canyon. We invite the reader to come along as we unveil the canyon's story.

One

THE EARLY HISTORY

For untold generations, Native Americans roamed the canyon formed by the Cache la Poudre River, hunting and trapping. Wildlife was abundant, and the river teemed with fish. Unfortunately for historians, these early adventurers left no record of their presence except some artifacts; it is unknown precisely who was there, and when. What is known about the history of the Poudre Canyon begins when mountain men, trappers, and explorers penetrated its wilds in the early- to mid-19th century.

A number of these men were French Canadian. Others came from the East after the Lewis and Clark expedition established the existence of vast acres of forests, substantial rivers and streams, and a variety of tribal inhabitants west of the Mississippi River all the way to the Pacific Ocean. The rivers attracted beavers, which in turn attracted trappers, for their pelts were in demand. One man, William Ashley, who owned the Rocky Mountain Fur Company, is known to have been in the Poudre Canyon area in the 1820s. Famed mountain man Kit Carson is said to have established a trapping base at the headwaters of the river in the same decade. More people came; by the latter part of the 19th century, the canyon hosted a number of settlers, mostly ranchers, and some tourist resorts as well. Chapter 1 tells stories of those early years.

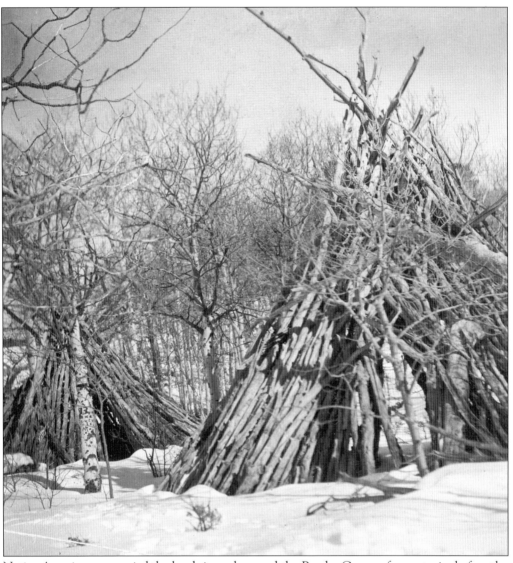

Native Americans occupied the lands in and around the Poudre Canyon for centuries before the first Europeans arrived. They left behind signs of their stay—arrow points, fire rings, at least one burial site—and these wickiups, photographed in Jackson County, Colorado, west of the Poudre Canyon. Unlike tipis that were made of lodgepole pines covered with animal skins and made to be moved, these wickiups were temporary shelters made from the most abundant material at the site, in this case aspen trees, and were probably covered with local vegetation. While none have been found within the canyon (they fall down and rot quickly or burn up in fires), they no doubt were used there in the past. (USFS.)

Indian Meadows, described by Norman Fry in his book, *Cache la Poudre: The River*, was a gathering place for Native Americans roaming in the canyon. About the naming of the large meadows, located near today's milepost 94, Fry said, "In the River's upper mountain parks . . . it seemed that the Arapaho, Cheyenne, and the Ute Indians had through the years camped, hunted, and fished. Even refugee Cherokees from the State of Georgia, I was told, had traversed the section looking for a new home. These really were the 'Indian Meadows' then!" Born in England, Fry arrived in Fort Collins in 1888 at the age of 17 on his way to try his hand at ranching with Eustace Dixon in the Poudre Canyon. He worked a variety of jobs in the canyon and had memorable experiences, which he later recalled in his book. (Above, FCLHA H06031; below, FCLHA H02321.)

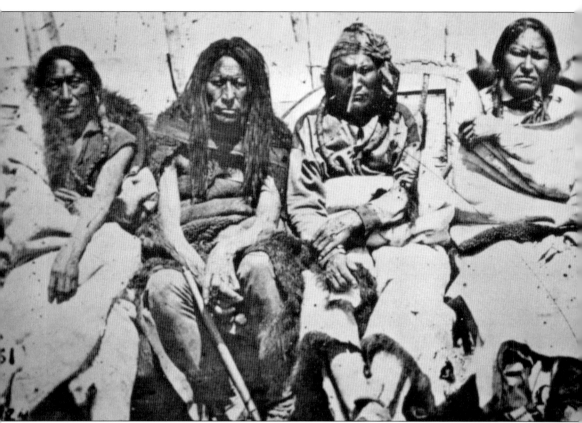

One Native American familiar with the canyon was Chief Friday Fitzpatrick, seated (right) in this photograph from about 1860. Educated among whites, Friday returned to his tribe in 1858 as chief of a large band of Arapahos who roamed the upper canyons of the Poudre. Because of his skill with both English and his native tongue, Friday often served as a guide or interpreter. By 1864, the military had forced the band to stay close to Camp Collins, near present-day Laporte, Colorado. On August 23, 1864, Indian agent Simon Whitely said he found the Arapahos "not actually starving [but] miserably provided with food," as the men were only permitted to hunt in a small range from which most of the game had disappeared. Because the agent and camp commander William Evans both agreed that the tribe was peaceful, Friday's band received permission to hunt along the South Fork of the Poudre, where they had hunted for generations, but their time in the Poudre Canyon was coming to an end. Exiled to the Wind River Reservation with his tribe, Friday died there in 1881. (FCLHA H05385.)

The first non–Native Americans known to spend time in the Poudre Canyon were fur trappers who came with William Ashley during the winter of 1824–1825. One of them, James Beckwourth, is pictured here. Beckwourth lived a nomadic life: born in Virginia, he joined Ashley's Rocky Mountain Fur Company to trap beaver in the Rocky Mountains. He later joined a Crow tribe, ventured to California twice, and was buried as a Crow on a tree-limb platform. (FCLHA H12366.)

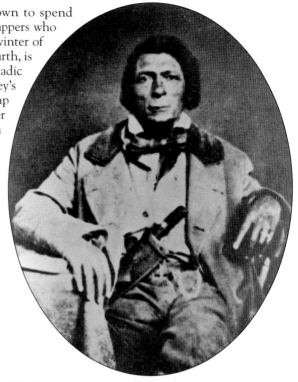

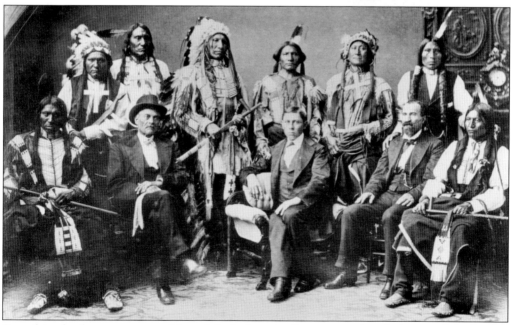

Seated in the front row, second from left, is Antoine Janis, an early inhabitant of the Poudre Valley. He and his father visited the canyon with Ashley and Beckwourth; father and son are thought to have trapped in the canyon in 1836. Calling the area "the loveliest spot on earth," the younger Janis later settled near Laporte. Janis was on good terms with several Native tribes and married an Oglala Lakota woman. (FCLHA H01919.)

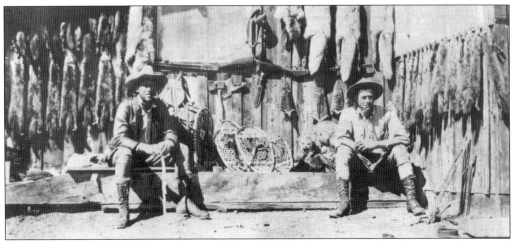

Lined up behind trappers Scotty Lester (left) and Ralph Koenig are pelts of martens, foxes, and bobcats, which they collected one season. The furs were hung up to dry after all flesh was carefully removed and then stretched. While high-volume commercial trapping collapsed when beaver hats went out of style, furs continued to be a money-maker for many local residents for years to come. (FCLHA H01581.)

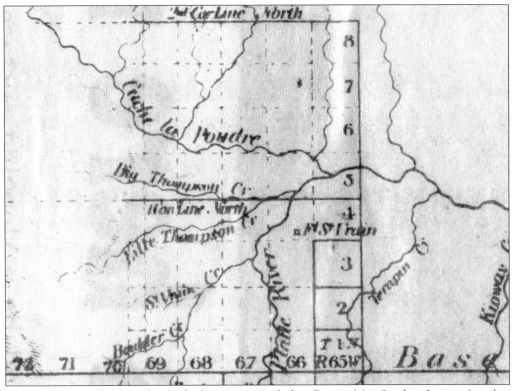

The Cache la Poudre River has had other names, including Pitaux. Maj. Stephen Long referred to it as Pateros Creek. Col. Henry Dodge stated that his 1835 expedition had "passed the mouth of the Cache de la Poudre," the first official use of its current name. This 1861 map of the Colorado Territory is the earliest map in the Fort Collins Local History Archive that includes the Poudre River name. (FCLHA CO00173.)

George W. Pingree was born in Maine around 1827 and headed West in 1856. Pingree made his way West by working in tie-cutting camps in Missouri and Minnesota. Railroads were expanding westward; each new mile of track required around 3,000 wooden crossties. Interrupted by the Civil War, Pingree—who had scouted with Kit Carson and served with Col. John Chivington during the Sand Creek massacre in 1864—came to the Poudre Canyon in 1867 to hunt and trap. Noting the abundance of trees that were an ideal size for railroad ties, Pingree contacted the Union Pacific's tie contractors, Isaac Coe and Levi Carter, and was soon running a 40-man tie camp for them in what is now Pingree Park. South and west of Rustic, the park is managed by Colorado State University. He died in 1921 and is buried in Platteville, Colorado. (History Colorado, Denver, Colorado, 10028796.)

As the next few photographs from the Nelson Tie Camp, located in Jackson County, Colorado, show, tie hacking was a manual business. The images were taken during a demonstration in 1926, using time-honored processes. Trees were chopped down and cut to tie length with one- or two-person saws known as "Old Gappies." (FCLHA H05172.)

Once the tree was cut down, the branches were cut off with a double-bladed axe and the log scored to the correct width. Some tie hackers snapped a chalked string to mark the log for scoring, but the better hackers could "eye up" the tree perfectly. Then they used a broad axe, with a 10- to 12-inch blade, to work the log to the proper dimensions, as shown in this photograph. (FCLHA H05144.)

The bark was then peeled off using a "spud" or "spud peeler," a long wooden-handled tool with a curved blade on the end. The log was then cut into finished lengths. A good tie hack could cut 40 ties per day; it is said that George Pingree could cut 100 per day. Tie hacks were paid 10¢ per tie, a good daily wage for its time. (FCLHA H05147.)

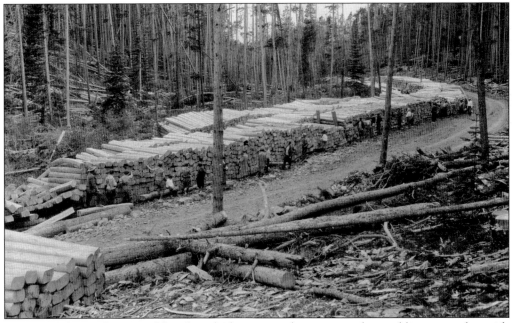

Ties were taken to "strip roads" and stacked using a pickaroon, a tool resembling an axe but with a metal point on one end, ready to be carried downstream to market. The river was dubbed the tie highway. Every year during the 1870s and 1880s, about 100,000 ties were cut out of the Poudre Canyon. (FCLHA H05158.)

The ties were banked along the creeks and rivers, where they waited for the heavy spring runoffs caused by snow melt. As shown in this photograph, the ties were then pushed into the streams by tie drivers who poled the ties down the river, a very dangerous job. A boom was placed across the river to stop the ties at the take-out point. (USFS.)

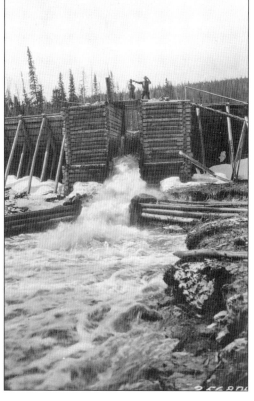

Some small creeks, like Stuck Creek in northern Larimer County, were too small to float the ties even in the spring. To help them along, splash dams were built to back up enough water to make a tie drive possible. When the sluice gate was opened, the ties were quickly pushed into the flow, flushing them downstream. By 1890, most of the right-sized trees were gone, radically slowing down the tie business in the canyon. (USFS.)

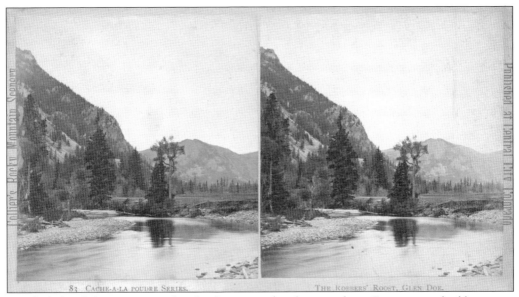

Not far behind the trappers and tie hackers were the photographers. Stereo views had become a national craze, and the Rocky Mountains were a popular subject. Joseph Collier was an important early photographer of Colorado mountains, one of the first to photograph the Poudre Canyon, producing his "Cache-a-la-Poudre Series" in the mid-1870s. (MEM.)

The April 22, 1874, *Fort Collins Standard* reported on Collier's images: "We have received . . . some very fine stereoscoptic [sic] views of the Cache La Poudre scenery, taken by Mr. J. Collier. These views are unsurpassed in grandeur by any we have ever seen, not excepting those of the far-famed Yosemite." This is a Collier stereo view of a hunting cabin in the Poudre Canyon. (MEM.)

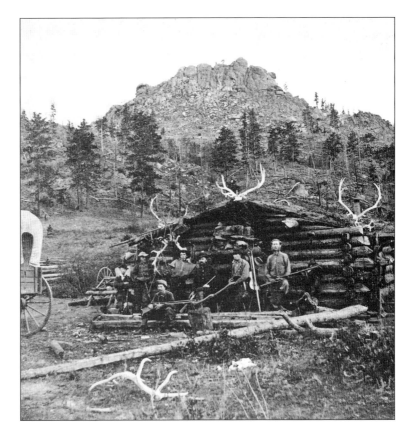

Not to be outdone by traveling photographers, local photographers began making images of the canyon. This image of a small party enjoying the river was taken around 1880 by Lewis Land, a Bellvue photographer. Bellvue, founded in 1873, is the small town located near the mouth of the Poudre Canyon. (MEM.)

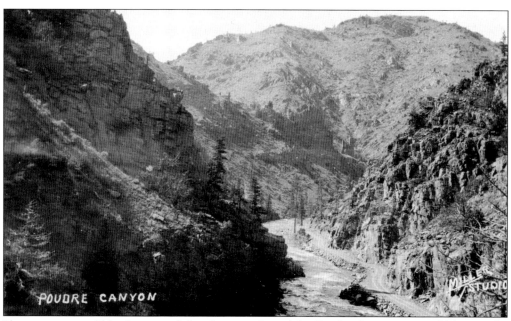

If one person could be designated the photographer of the Poudre Canyon, it would have to be Mark Miller. Miller had a photography studio in Fort Collins from 1914 until 1970. Combining work with vacation, Miller took thousands of images of the canyon, including this one from the early 1920s. Miller's life and images have been featured in another work from Arcadia Publishing's Images of America series, *Fort Collins: The Miller Photographs*. (MEM.)

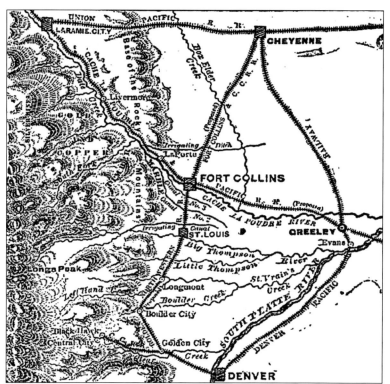

The *Fort Collins Standard* newspaper of April 1, 1874, displayed this map drawn by Franklin Avery depicting a potential railroad line through Poudre Canyon, postulating that the line was "only a matter of time and finances." A subsidiary of Union Pacific Railroad attempted to build a line through the canyon to Salt Lake City, Utah, starting work in February 1881. In the fall of 1882, with only four miles of grade completed, the effort was abandoned. (MEM.)

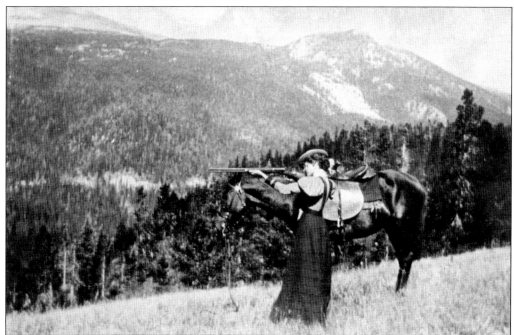

As fast as roads pierced the canyon, residents took advantage of its recreational opportunities. Abundant wildlife made hunting a popular pastime, and women could shoot as straight and true as men. Here, Charlotte Whaler Bryant is shown with her rifle while on an 1898 camping trip. (FCLHA H12223.)

Trout fishing has always been popular in the canyon. Here, three young men, probably campers, enjoy some of the trout they caught during the day. This photograph was taken by a member of the Colorado Mountain Club around 1920, as part of a lantern-slide series on the Poudre Canyon. (FCLHA COMT1-48.)

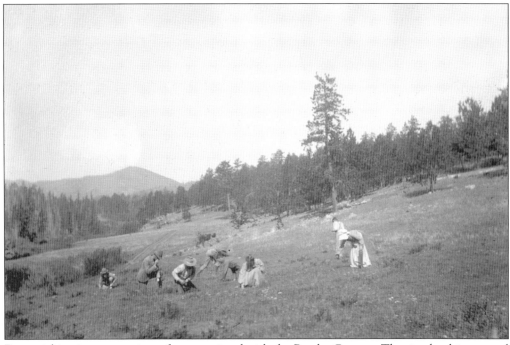

Berry picking is not a pastime often associated with the Poudre Canyon. That is why this pastoral scene is so special. This photograph was taken near the Michigan Ditch in the upper canyon around 1900. (FCLHA H15934.)

Two

Early Roads

Tie hacking—cutting, and delivering railroad ties to keep up with 19th-century expansion into the West—was the catalyst for development of roads through the canyon, but interest in the prospect of gold drove road building as well. This chapter looks at the earliest known roads that led to and through the canyon, built to haul logs on and get prospectors to the mines. One early road charged a toll. Later, the roads lured tourists to resorts.

The first road took travelers to the upper canyon through Livermore, because end-to-end access to the canyon was blocked by a section called the Narrows. Small settlements of note sprang up as the canyon became more accessible.

Like much of the Old West, the canyon area's history is full of tales about colorful people, adventurers—successful and otherwise—and lively events.

By the time the roads appeared, the Native American populations were scattered and diminished, losing the battle for their hunting and trapping grounds and leaving the land to the late-coming settlers. It did not take long, once the roads were open, for residents of the towns below to begin seeing the canyon as an area for business, sport, and recreation.

At first, the roads were used to reach the mining camps that sprang up near the Upper Canyon. This occasioned the building of hotels, which this chapter visits, along with the people who built them. Ranches opened along the canyon, followed by stores, post offices, and schools. Some of the ranches still run cattle in the area. Although the mining camps are gone, a few of the communities remain.

Robert Roberts, an early settler, arrived in Colorado in 1874. Meeting Russell Fisk in Greeley, he agreed to become caretaker for Fisk's land in Livermore. Roberts decided to stay, acquired his own ranch land, and was so reluctant to part from his large family that he once walked long miles home from Greeley after starting on a trip without them. Roberts Ranch is today designated a Centennial ranch, one which has been operated by the same family for over 100 years. (FCLHA H06904.)

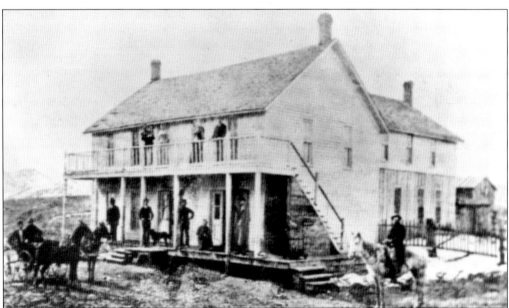

The Forks Hotel came to be because weary loggers making the two-day trip from Pingree Hill, wanting a rest stop, supplied Roberts with lumber, which he and his son George hauled to the site, to build it in 1874. An all-night dance celebrated the grand opening in 1875. The hotel had 10 small bedrooms and a restaurant, and the walls were insulated with sheep's wool. (FCLHA H00963.)

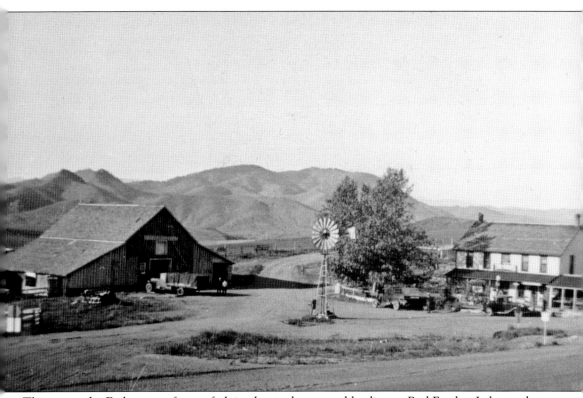

The name, the Forks, came from a fork in the road, one road leading to Red Feather Lakes and the other to the Virginia Dale stage station. In the beginning, it was home to a general store and a reception hall, often the site of weddings, dances, and church services. The first church service in Livermore was held there in 1875, with about a dozen people in attendance. A large stable housed travelers' horses, and a spring house kept milk and butter cool. A favorite stopping place for Sunday drivers after the arrival of the affordable automobile, the Forks often hosted caravans of families, puffing along in their open cars at 25 miles an hour and pausing there on their way to the mountains. For more than a century, it was a community gathering place. In 1985, the historic building burned to the ground. Despite the loss of so much history and many memories, the community determined to rebuild, an effort led by Robert Roberts's great-grandson, Derek Roberts. It reopened in 1990, serving customers as the Forks Café—still a favorite stopping place. (Rene Lee.)

Russell Fisk, a Civil War veteran, came to Greeley in 1870 with his family and his brother George; their father, Richmond Fisk, was a founder of the Union Colony. By 1871, Fisk had relocated to Livermore. A busy entrepreneur, he built a hotel and store and ran a cattle herd. Fisk eventually moved to Fort Collins, where he had a store, and died in Denver in 1909. (FCLHA H20389.)

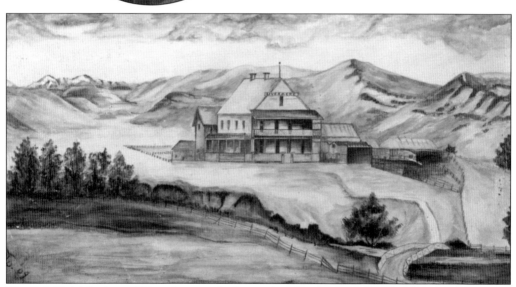

The Fisk Hotel, built in 1871, is charmingly depicted in this painting. The first hotel in Livermore, made of logs, it was said to leak very badly when it rained. It also harbored pack rats, which, the story goes, were dispatched with Fisk's Civil War sword. This larger, more solid building, called Livermore House, replaced the earlier version and still stands as a private home. (FCLHA H111011.)

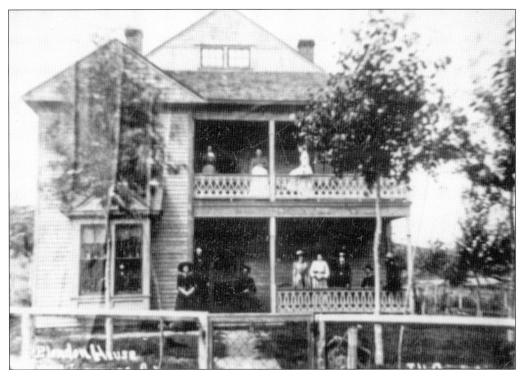

Built in 1890 by William Brelsford, the Livermore Hotel also had, like the Forks Hotel, 10 small bedrooms and a general store. It supplanted Livermore House as a hostel for travelers. Frieda Miller, a later occupant, told stories of seeing a ghost in the building, which later became a private home. (FCLHA H12153.)

This image shows the Livermore Hotel (left) and the Livermore meeting hall (right). Demolished during World War II for its cache of scarce materials, the meeting hall hosted many a lively dance in its day. Undeterred by winter weather, dancers would come from miles around to enjoy the camaraderie. At one point in the 1970s, a new owner of the hotel endeavored, unsuccessfully, to bring it back to life. (MEM.)

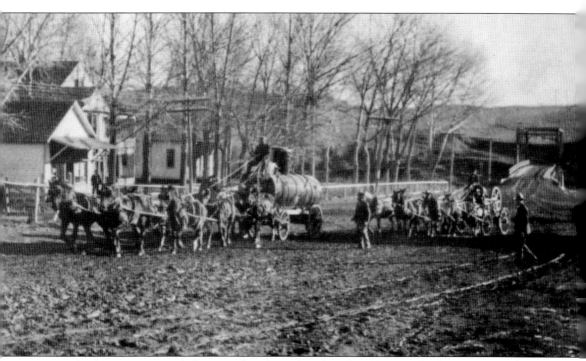

Tie hackers, miners, and their suppliers brought a lot of traffic past the buildings in Livermore. Stages, first horse-drawn and then "auto-stages," started to run daily to Rustic and the canyon, carrying people, materials, and mail. As work began on the major water projects in the Upper Canyon, heavier equipment had to be brought in by freighters, mostly using four- and six-horse teams. This photograph is thought to show equipment on its way to the construction site of the Laramie-Poudre Tunnel in 1909 or 1910 (for more information see chapter 8). Stewart Case wrote that the first wagon was carrying an air-compressor tank and the second wagon the compressor itself, which would be used to power the rock drills used in the tunnel construction. (Rene Lee.)

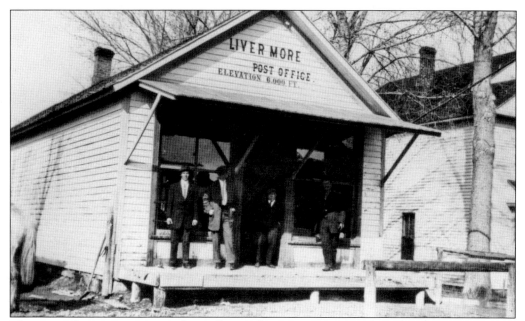

The post office in Livermore relocated several times, starting in the Fisk home in 1894 with Russell Fisk as postmaster. Here it is on the north side of the road, just west of the Livermore Hotel. Mail was delivered by horseback in the beginning, later by horse-drawn wagon. Once, a carrier encountered a dismayed child who, when no mail appeared, lamented that they were out of paper for the outhouse. (FCLHA H09845.)

Standing behind the cash register at the Livermore store and post office is Lawrence Nightingale, who came to the area with his family in the late 1890s. Nightingale not only helped out with the store and the hotel, he also claimed his own homestead. When the hotel changed owners, he stayed on. (FCLHA H00734.)

Josephine Lamb was a colorful inhabitant of the area, a teacher and rancher. Born in 1897 in Soldier Canyon, now under Horsetooth Reservoir, Lamb rode six miles, a 90-minute trek, to attend Cache la Poudre High School. She earned teaching credentials at Colorado State College (now University of Northern Colorado) and taught in rural one-room schools for decades. She established a homestead at the age of 21. A true frontier woman, she drove cattle herds, roped cows, drove a horse team and wagon, chopped wood, cooked meals on a wood stove, built fires, and hunted with the best of them. She was an adept fisherwoman as well and could dance the night away if the occasion called for it. She was also an amateur painter and a published poet. She died in 1973. (FCLHA H00503.)

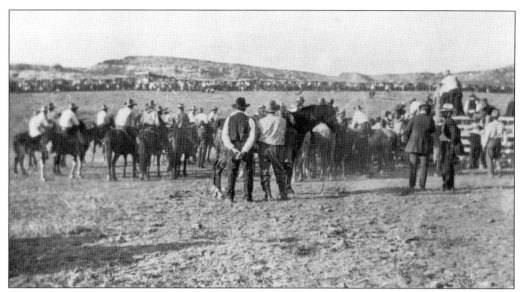

Where the Livermore Community Hall now stands there once was a rodeo ground. Livermore rodeos were held there on the Fourth of July from 1924 to 1934. Family affairs, they featured games for children, ladies' races, and more traditional rodeo events. Spectators sat atop their cars to watch the goings-on, and after the rodeo, participants and spectators went to a dance. (FCLHA H11386.)

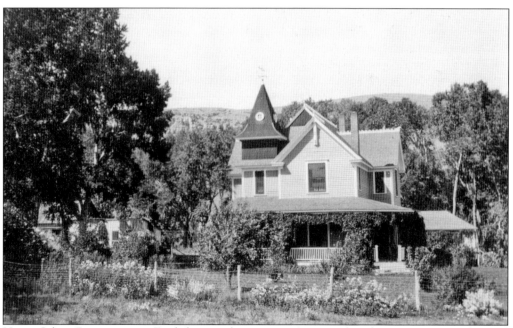

Harry Gilpin-Brown was an Englishman who came to America for adventure. He soon learned Western ways and acquired a ranch of his own, where he managed a sizable herd of cattle and did much of the hard work himself, roping, branding, and herding. This is the main house on the property. He was related to the first governor of Colorado, William Gilpin, and his brother Charles was a Larimer County commissioner. (FCLHA H21822.)

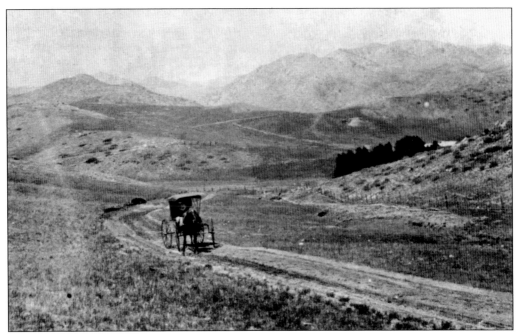

Wagons had a rough time on rural roads, as this image shows. This wagon is heading along the Livermore Road (now Red Feather Lakes Road), a narrow, rutted track that clearly challenged horses. Roads did not improve much when cars entered the cultural scene—they might have been more stymied than the animals. (FCLHA H01379.)

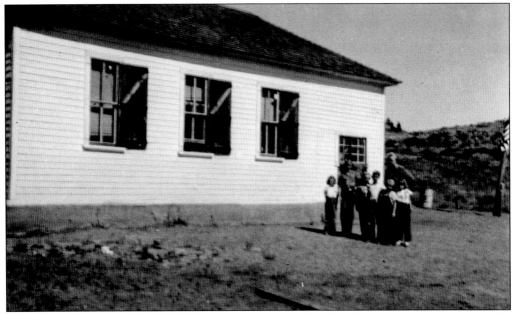

In the early 1900s, Robert Swan tried to ride a horse to school but found the animal too large for him to manage alone, so he went with his father by horseback to a neighbor's home and walked from there. Adams School, which he attended for a time, was a one-room schoolhouse typical of the times. The lone teacher not only taught but built fires and drew water. Pupils came from miles around. (FCLHA H03824.)

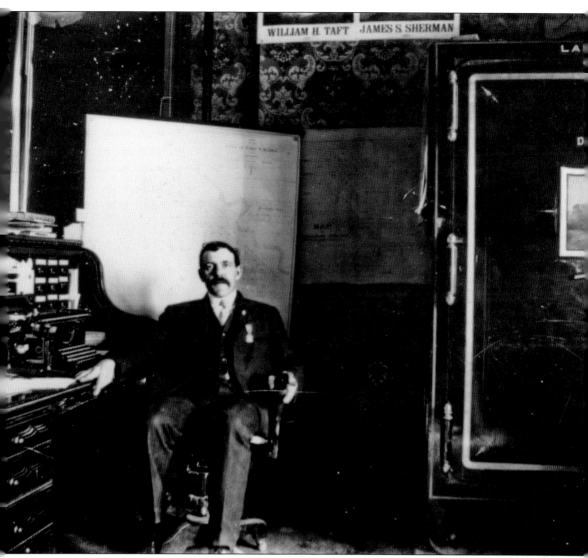

In 1888, Elizabeth St. Clair homesteaded 320 acres and moved a log building to the site. She named the location Log Cabin. In 1896, a change put Log Cabin directly on the road to Rustic. St. Clair took advantage of the opportunity and opened her home to travelers. By 1903, she had added a second building that served as a store and post office. Log Cabin, Colorado, was on the map. Stewart Clayton Case came to Colorado in 1886 from South Dakota. Working first as a teacher and then as Larimer County assessor, shown here in his office between 1907 and 1909, Case saw the value of the Log Cabin property and purchased it from St. Clair in 1910. He and his family operated it until 1918, a peak decade for the hotel, store, and post office. Case would later buy and run the Forks Hotel. (FCLHA H00161.)

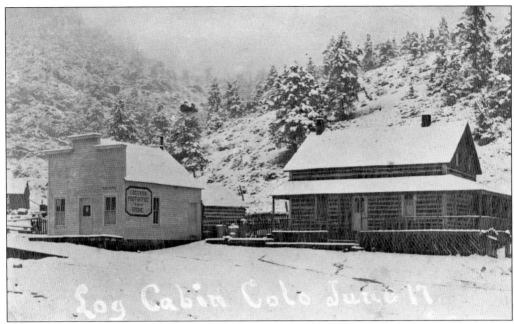

The two main buildings were moved to the site from other locations. St. Clair moved the log building from the Ashley Grange, a place that trained the younger sons of English nobles (remittance men) in ranching. Case put a one-story addition on the back of the building for his family's use. (MEM.)

This photograph, apparently taken by Stewart Case, shows Log Cabin during his tenure as owner. Besides the hotel and store on the right side of the photograph, a livery barn and cattle and sheep sheds are visible. Rates were reasonable: 25¢ for a meal, 25¢ for a bed, and 50¢ to stable and feed a horse. (Rene Lee.)

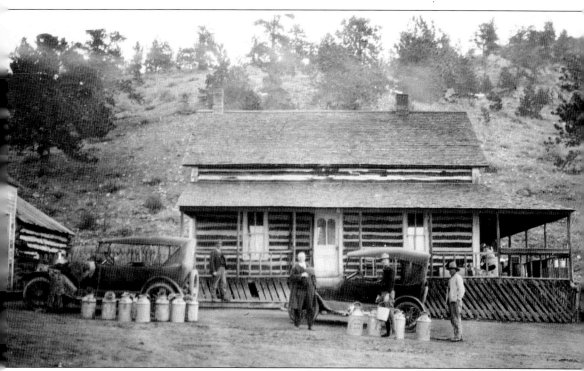

Log Cabin was a convenient transfer point for a considerable amount of freight, but this freight is unusual. Trout fingerlings, probably from the fish hatchery in Fort Collins, were being moved to Red Feather Lakes in these containers, called fish cans. According to the information on the photograph, the fish were moved by automobile to Log Cabin and then transferred to a buckboard for the trip to Red Feather Lakes. If the cans started to warm up, handfuls of snow were added to cool them down. (Rene Lee.)

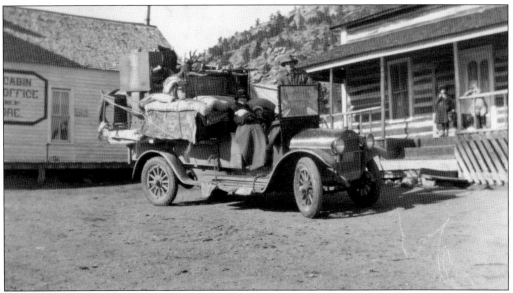

In the 1922 mail-route bid, Jess Scott and his brother Ben were the winners of the Fort Collins to Poudre Canyon route. Each day, one brother would start at Fort Collins, the other at the Zimmerman Hotel in the Poudre Canyon. They would meet at Log Cabin and trade vehicles. Their slogan was "We Haul Everything." Here is one of their vehicles, a 1927 White truck, at Log Cabin. (FCLHA H07593.)

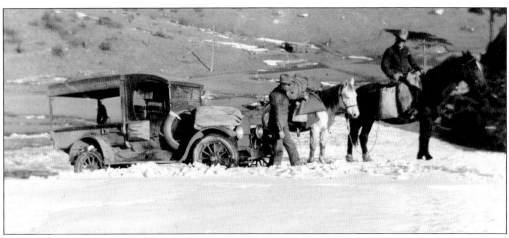

Improving roads and better automobiles made the trip from Fort Collins to the Poudre Canyon shorter, but snow still gave the advantage to the horse. Here Jess Scott stands near his 1920 Commercial Dodge that is stuck in the snow, the mail handed off to Harry Sommerton and his horse for delivery to Rustic. (FCLHA H07594.)

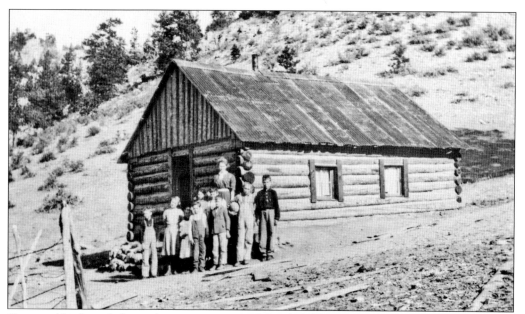

Case used his knowledge and experience to teach local children in this small log building, located a short distance northeast of the hotel. In 1931, the hotel burned down and was never replaced. Today, all that is left of Log Cabin is a historic marker and the re-sided schoolhouse across the street. (FCLHA H03199.)

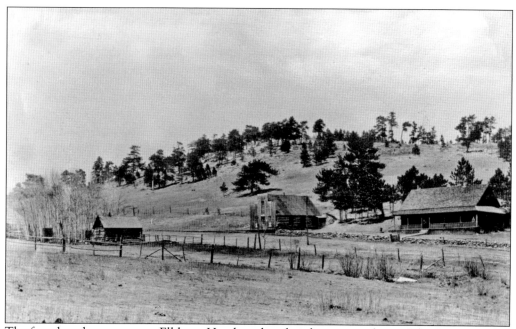

The fact that there were two Elkhorn Hotels makes their history confusing. The first opened in 1874, financed by some Greeley bankers. It was never really successful, and a change in the position of the road finished it off. In 1887, Willis Miller filed a 160-acre homestead claim on Elkhorn Creek about five miles west of Log Cabin. Soon a hotel and store, shown here, were serving the miners and freighters heading into the canyon. (FCLHA H02306.)

As the Manhattan gold field slowed down (see chapter 3), postal authorities moved mail service to Elkhorn, adding to the services provided by the store shown in this photograph. In 1917, the Millers traded the Elkhorn for the Log Cabin property, and the hotel operation ceased. The old hotel building burned down in 1965, but the property was used for several different purposes, among them timber-cutting and fox and mink farming. (FCLHA H01183.)

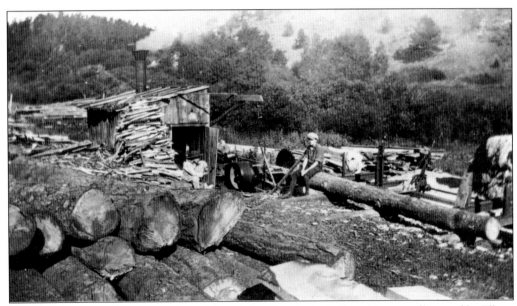

Ranches, farms, and businesses dotted the road to Rustic, including this sawmill owned by Elbert Robinson. Located on Manhattan Creek, it was known as the Elkhorn Lumber Company. The two young boys pictured here around 1926 are thought to be Charles Robinson (left) and Jack Boretz, sitting on the log. Elbert Robinson's head and hat are barely visible in the saw pit on the right side of the image. (FCLHA H11407.)

The last stretch of the road to Rustic, called Pingree Hill, was terrifying. The hill was so steep that teamsters would often cut a log to drag behind the wagon as a makeshift brake. Automobiles, even Stanley Steamers, had problems with the hill. An accident in 1910 killed one man and injured another when a Stanley's brakes failed on the steep section. Though the drop is sharp, the views of the canyon are suburb. (FCLHA Ha1139.)

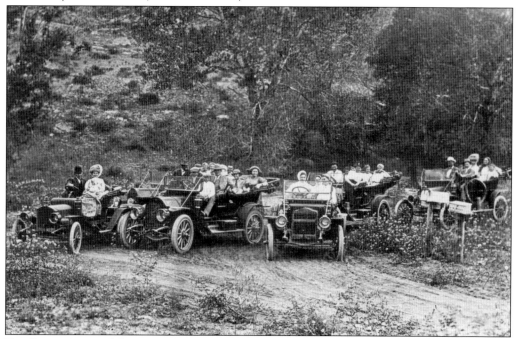

Finally, in 1911, work began to shift the road to a route with a gentler grade. Completed in 1912, the new Pingree Hill Road made a safer—but still spectacular—trip for automobiles, which were beginning to supplant horses. In this photograph from about 1913, a group of Maxwell, Jackson, and Ford owners have apparently gotten together for a Sunday picnic along the road. (FCLHA H09426.)

CACHE-LA-POUDRE AND NORTH PARK
TOLL ROAD.

The only graded road from

Fort Collins to North and Middle Parks

—*via*—

LA PORTE, LIVERMORE, ELKHORN, PINGRE'S CAMP, RUSTIC HOUSE, POUDRE FALLS, CHAMBERS LAKE, CAMERON PASS AND MICHIGAN CREEK TO

CRESCENT CITY,

And from Chambers Lake *via* Grand Pass to

LULU CITY.

The best Thoroughfare in the Rocky Mountains.

On this route are good hotels, fine camping grounds and plenty of timber. No point within 1000 feet of timber line. Fort Collins the nearest railroad and

BEST OUTFITTING POINT.

Thousands are waiting to go into the gold and silver mines,

THE RICHEST IN COLORADO.

The finest hunting and fishing grounds in the state are found along this route.

The Rustic House,

Forty miles from Fort Collins, always has a full supply of camp outfitting goods. The Rustic House is half way from Collins to Crescent City, North Park, and Lulu City, Middle Park.

Our motto is plenty of travel and low rates of toll.

S. B. STEWART.

With a way to the canyon down Pingree Hill, Fort Collins businessmen started clamoring for an extension of the road to North Park, at the time part of Larimer County. A number of alternatives were proposed; the winner was the Cache la Poudre and North Park Toll Road, incorporated in May 1879. Samuel B. Stewart was a member of the three-person board of directors, the man given the job of managing construction of a wagon road following the existing tie trails from the base of Pingree Hill past Chambers Lake, over Cameron Pass, and into North Park. By July 1880, the road was open for business, with connections to the new mining towns of Lulu City and Teller City. Advertisements like this one were running in Fort Collins newspapers. A reporter who took a trip along the road in July 1880 pronounced it a "good mountain road, far above average." Tolls were charged until 1902, when the road was opened free to the public. (FCLHA H11134.)

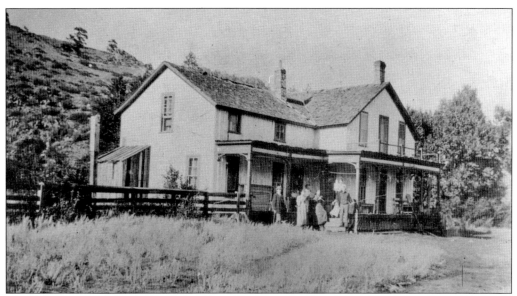

Samuel Stewart was an entrepreneur. He believed travelers would flock to his toll road and realized the value of a hotel at the junction of Pingree Hill road and the canyon toll road. On March 4, 1880, the *Fort Collins Courier* announced that Stewart was putting the finishing touches on his hotel, complete with a large kitchen from which travelers could get a bite to eat, as well as beds for spending the night. Stables and sheds were also available so that stage lines could change out their tired horses. Stewart named the hotel the Rustic House, though most people shortened it to the Rustic, and the name carried over to the little town that sprang up around it (see chapter 7 for more on the Rustic Hotel). (Above, FCLHA H00119; below, FCLHA H01288)

In the new century, land uses changed. Local Boy Scouts hoped to buy Pinecroft Ranch near Log Cabin, where they wanted to build a summer camp, from owner George Weaver. They held countless pancake breakfasts and other events to raise enough money. When they had raised about $10,000, planning to pay off the rest of the cost over several years with interest, along came Ben Delatour, a wealthy man who said this was as good a use for his money as any. He bought the ranch, covering the $10,000 already raised, and later helped both Camp Fire Girls and Girl Scouts buy land nearby for summer camps. Delatour died at 96 in Fort Collins. The old Zimmerman trail following Elkhorn Creek went through the Boy Scout camp land; even today Scouts might find remnants of the past such as tipi rings and a few old gravesites. (Both, MEM.)

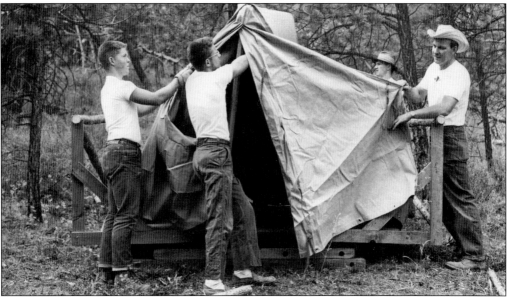

Three
THE MINERS

A decade after the wild rush to the veins of gold in California in 1849, Colorado experienced a gold rush of its own, starting around the Pikes Peak area and migrating north and west. But it was still later that mining came to Northern Colorado and particularly to the canyon area.

The discovery of gold in the 1880s brought eager miners to the area seeking their fortunes. Enterprising people soon got into the business. Samuel Stewart's wagon trail, called by the local newspaper "a splendid road to the mines" even though it was but a narrow, rutted trail, cost $3 for a wagon to pass through, but determined fortune-seekers used it heavily. Fort Collins businessmen invested in mines; newspapers declared that Larimer County would soon be "the richest mining county in the state."

Built on high hopes and great expectations, towns appeared: Manhattan, Lulu City, and Teller City. For a time, the towns prospered as miners did find precious metals. But the heyday of gold and silver mining in the canyon region was brief, for profiting from what was extracted was fraught with challenges—too many, eventually, to be overcome. This chapter is a tour of these erstwhile mining towns.

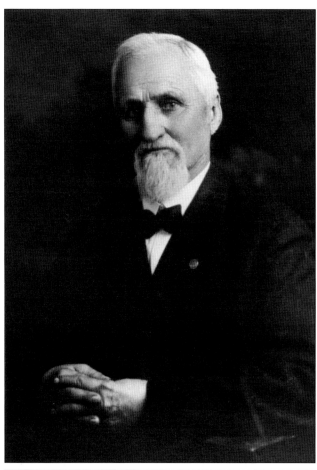

Benjamin F. Burnett, who was born in Illinois in 1838, came to Fort Collins with his family in the fall of 1879. Even though Burnett owned a meat market in town, he was fascinated with mining and followed local mining developments closely, even buying and selling claims as shown in his advertisement from about 1878. When Joe Shipler, another local resident, found silver in eastern Grand County, Colorado, in 1879, Burnett and rancher William Baker financially backed the operation, naming the new mining town Lulu City after Burnett's beautiful black-haired oldest daughter. A few years later, Burnett would be part of the group that would develop the gold mining town of Manhattan, Colorado. (Left, FCLHA H09753; below, FCLHA H00049.)

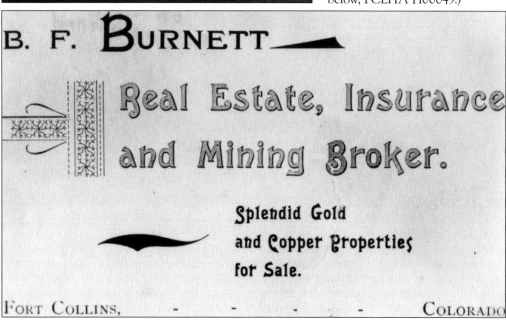

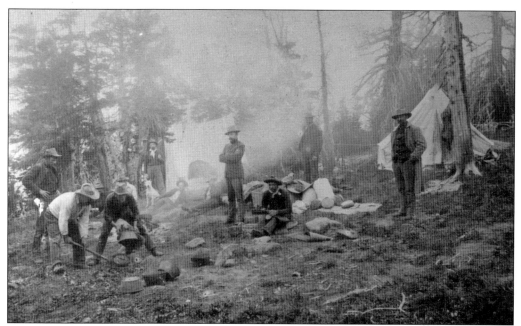

Prospectors poured into Lulu City from Fort Collins and other places, many living in camps like this one, probably right at their claim sites. But a town infrastructure was established quickly. In no time at all, Lulu City had 100 blocks platted, with sawmills, a hotel, stores, and even its own justice of the peace and post office. (FCLHA H11156.)

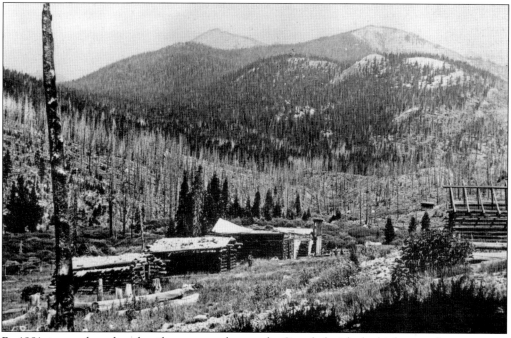

By 1881, it was clear that the silver ore was low grade. Coupled with the high cost of transporting the ore, especially in winter, the operations were marginal at best. Four years later, Lulu City was largely deserted, except for Joe Shipler, who lived there for 30 years. The photograph shows what remained of the town in 1889. (FCLHA H11158.)

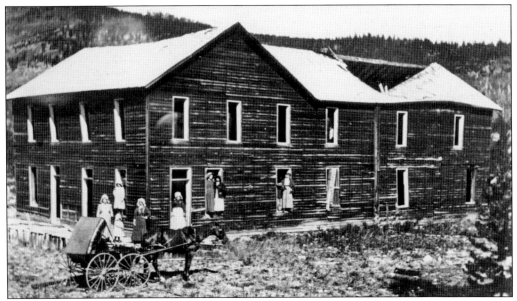

Teller City, Colorado, was another boom-and-bust silver-mining town. Located in what is today Jackson County, the town was founded in 1879 by "Old Cush" Madore Cushman. By 1880, it had a population of over 2,000, multiple saloons and log cabins, and even a 40-room hotel, shown abandoned in the top image. Like Lulu City, it was essentially deserted by 1885. The photograph below shows the ghost town around 1904, with a few cabin remains still visible. While neither Lulu City nor Teller City made many millionaires, they did bring thousands of miners, freighters, and tradespeople through Poudre Canyon. The traffic hurried construction of Stewart's toll road over Cameron Pass to Teller City, with a connection to Lulu City. (Above, FCLHA H04866; below, FCLHA H11159)

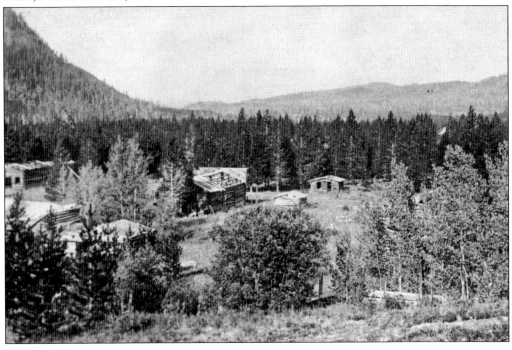

In the late 1800s, mining and mining claims could be very informal. A claim had to be clearly staked, documented, and filed with the appropriate authority, along with a small fee. This gold-mining claim was filed by Russell Fisk in 1874. It is on cheap lined paper, folded in fourths. Inside it describes the location of the claim, which was in Larimer County between a "specific cottonwood tree" and the "so-called Moose Cabin." (FCLHA.)

The mining process could also be simple. Here, Albert Case brings ore up from his gold mine, probably in the Manhattan Mining District, while his grandsons Ivan (assumed left) and R'Lee [sic] look on. Albert Case was the great-grandfather of Stanley R. Case, who wrote *The Poudre: A Photo History* in 1995. (FCLHA H08616.)

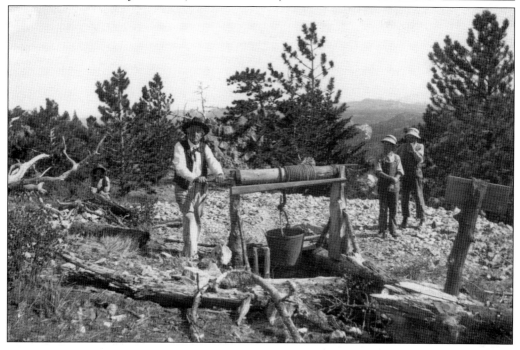

Gold and silver seemed to be bypassing Larimer County. Something needed to be done. In mid-1886, a group that would become known as the Fort Collins Mining Company circulated a prospectus. Anyone willing to pay $5 a month for four months for the purpose of hiring two prospectors to work in the mountains around Fort Collins would share in 75 percent of the value of any claim they discovered—25 percent went to the prospectors. Some 20 such shares were sold, bought by some of the wealthiest people in Fort Collins. Abner Loomis (shown here), president of the Poudre Valley Bank and a prospector in his younger days, was chosen as chairman. Prospectors John H. Dubois and Isaac R. Blevins were sent out to find the company's fortune. They worked in the foothills all summer. On September 3, 1886, with great enthusiasm, the company announced that the prospectors had found "gold in fair quantities" 45 miles northwest of Fort Collins. Within days, additional prospectors were heading for the site, optimistically named Manhattan. (FCLHA H20593b.)

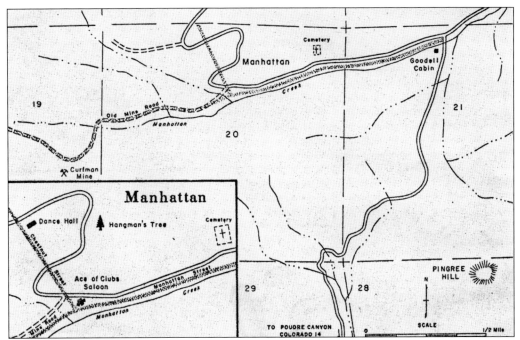

At first, Manhattan flourished. The enthusiastic investors laid out a plat for the town they envisioned, which would, they thought, rival Fort Collins. On this map, from an article written by Evadene Swanson, the location of Manhattan, north and west of Poudre Canyon, is shown in an enlarged detail. The small map at left identifies some landmarks. (FCLHA.)

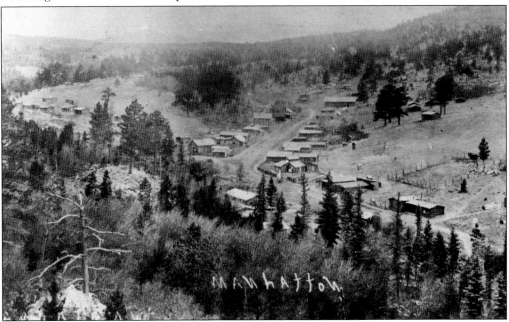

During the first flush of success, with gold coming in at up to $400 a ton, a sizable sum at the time, the town grew, as is evident in this photograph from about 1888. In the beginning, up to 300 mining claims were filed; some of them did produce gold for a time. A newspaper, the *Manhattan Prospector*, was among the enterprises—though it lasted not quite a year. (FCLHA H02000.)

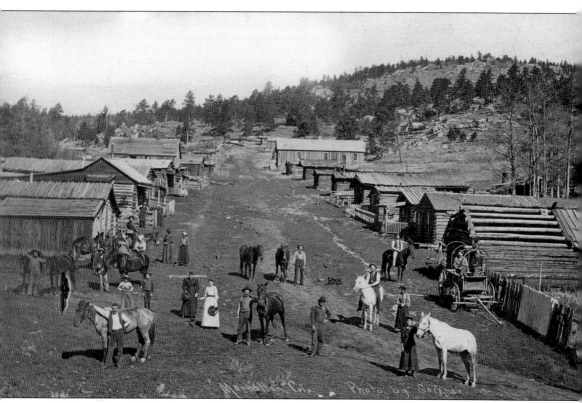

At the center of this photograph, standing beside two horses, is George Ragan, one of the eager prospectors who arrived in Manhattan to make his fortune. No other individuals are identified here. According to Stanley Case, this photograph was taken in 1888, when people were still hopeful about the future. Set at the junction of Manhattan's major streets, it has become the iconic photograph of Manhattan at its peak. (FCLHA H01992.)

In this image, the building is not identified, but it is probably the claim house for a mine. The sluice run is visible at right. The mining claims in the area were scattered, and they had colorful names like Bullfrog, Honeymoon, Joker, Little Tipsy, and Tidal Wave; Loomis's mine was called the Monte Cristo. (FCLHA H16716.)

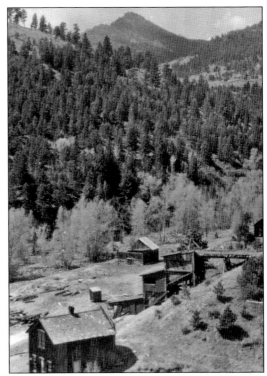

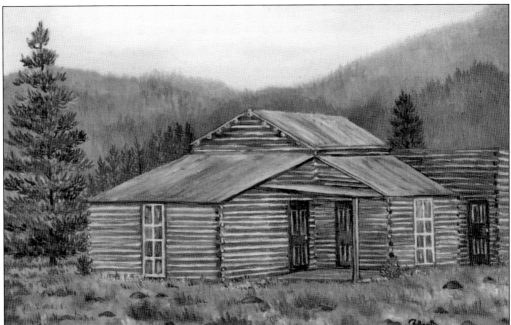

The arrival of so many miners in a short time required accommodation; thus, the Manhattan Hotel, shown here in a painting, was quickly erected. No buildings remain on the Manhattan site today, though some, like the hotel, were moved and repurposed in the canyon. It is a true Colorado ghost town. When the costs of transporting the precious metal as well as the costs of digging ever deeper became prohibitive, the miners abandoned their dreams. (FCLHA H07400.)

Nothing is more evocative of the Old West than a false-front building, and Manhattan had its share. This one, a general store, served a population of up to 2,000 at one time (source numbers vary). Transporting goods to sell at the store was as challenging as transporting the ore, over deeply rutted, narrow roads impassable in winter. The general store was owned by Benjamin Burnett. (FCLHA H07583.)

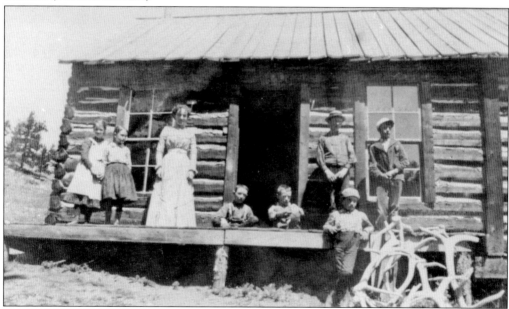

For a time, Manhattan drew enough people to warrant its own school. Shown here from left to right are students Mildred Goodell, Inez Robinson, Minnie Faust (teacher), Harry Goodell, and Elbert Robinson. Frank Goodell stands in front of the porch. As the population dwindled, more so after two men were killed in a mine explosion in 1892, the school became insupportable and was moved to nearby Elkhorn. (FCLHA H14671.)

Horses were essential to life in the 19th century and certainly to the miners. The animals worked for their livelihood, hauling wagons, carrying riders, and transporting goods, so a blacksmith was necessary, and Manhattan soon had one as this advertisement shows. The town also had a saloon, the Ace of Clubs, and about 40 other buildings. (FCLHA.)

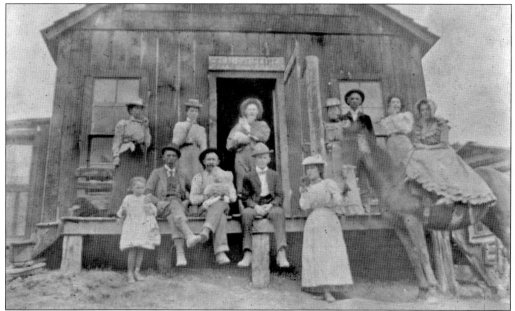

Manhattan's post office survived until 1900. A boom occurred in the late 1890s, when another productive vein was discovered, but it did not take long for the excitement to die down. No one is identified in this image. For a time, mail arrived in the mining towns thanks to John McNabb, who carried a backpack of up to 100 pounds over Cameron Pass, even on snowshoes in winter. (FCLHA H00983.)

One of the most memorable characters ever to populate the area, Lady Catherine Moon came to Colorado from Ireland in 1883 as Catherine Grattan Lawder. Penniless, she went to Manhattan, where she worked odd jobs but soon married a miner named Frank Gartman. Not long after her marriage, she took a job nursing a British peer, Lord Cecil Moon, and quickly divorced her husband to marry Moon, thereby gaining the title that she kept the rest of her life even though the couple divorced several years later. With money from an inheritance, the Moons bought a ranch, but Catherine liked ranching life better than her husband did. When they split, she kept the ranch (and paid Moon alimony), which she ran successfully for many years. Known as a high-living woman with a generous heart, she died in Fort Collins in 1926. (FCLHA H00543.)

Although it was never used—at least there are no records indicating otherwise—Western justice was at the ready, just in case it was ever needed. The hanging tree (or hangman's tree), the largest tree of its type in the vicinity, was probably so designated much later than the peak period of Manhattan's prosperity. (USFS.)

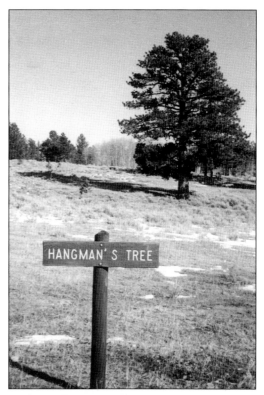

A legendary Manhattan character, John Brinkhoff, known as Rattlesnake Jack, is one of three people identified in the Manhattan cemetery. He had a mine in the area, claimed in the 1890s, which he worked for up to the $100 annual production required to keep it. When he died in 1970, he had a Western-style send-off, with rifles shot into the sky and a bugler playing "Taps." (FCLHA H19308b.)

John Zimmerman, shown here, and his brother Michael arrived in the Poudre Canyon around 1881. Though John would later become known for his Keystone Hotel resort, when he arrived he was searching for gold. It would take awhile, but in 1888 the brothers opened their Elkhorn Mine, north of milepost 89 on Colorado Highway 14. (FCLHA H0550z.)

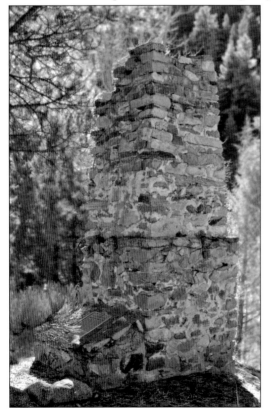

The Zimmerman brothers had a problem common to all the miners in the area—low-grade ore and expensive transportation. The brothers decided to build a stamp mill, a machine that breaks the ore up by pounding it with heavy stamps. The gold was recovered by washing the slurry over a mercury-coated copper plate. The mill was in operation in 1890, but an 1891 flood destroyed it, leaving just the chimney. It never reopened. (MEM.)

Four

Building the Poudre Canyon Road

In 1903, the Larimer County commissioners released money for the construction of a road from Loveland through Big Thompson Canyon to the hard-to-reach Estes Park Valley. The hope was that the road would increase tourism to the area. A single-lane road was in place within a year, and tourists began flowing into the Estes Park area. Fort Collins was envious.

By 1911, arguments were raging in Larimer County. Fort Collins wanted the county to appropriate funds and allocate convict manpower for a tourist road along the Poudre River, running from the mouth of the canyon to Rustic, where it would connect to the existing road from Livermore and Log Cabin and then over Cameron Pass, meeting a road being built from Walden, Colorado. Loveland was happy with the current situation and wanted the money and effort spent on improving their existing road. Finally, in June 1912, the county approved funding for the first section of the Poudre Canyon Road, and by November 1912, there were 50 men on the job, mostly convicts supplied by the state penitentiary system for 48¢ per day per convict. Loveland kept pressure on the county to move the funding to their improvement projects. In 1913, their successful lobbying forced the Fort Collins Good Roads Association to raise private funds to continue the work.

The effort to get through the Little and Big Narrows in the lower canyon was extreme, almost stopping the project completely, but by October 1920, the road was completed to Rustic. In August 1926, the connection of the road to Walden was celebrated with a picnic at Cameron Pass. This chapter tells the story of how the canyon road finally became accessible from one end to the other.

The design called for a 12-foot-wide road at water grade with turnouts at every curve. This photograph shows an automobile on a section of that early road, around 1913, below the waterworks. As the image illustrates, the earliest roads left considerable room for improvement. Stories abound about hair-raising wagon journeys—in Big Thompson Canyon, the road was so narrow in places that when two stages met, one would sometimes have to be dismantled, lifted off the road, and then reassembled after the other had passed. As with automobiles later, the vehicle going up always had the right of way. (USFS.)

The first major barrier in the way of completing the Poudre Canyon Road was the Little Narrows section. Much of the rock was blasted away to form the road, and then the decision was made to tunnel through one section. The photograph above was taken about March 1916, just as the tunnel work began. Named the Baldwin Tunnel after Charles Baldwin, supervisor of the project, it was completed in June 1916. The tunnel—only 14 feet wide—was used with great excitement by drivers. At bottom, Edgar Headlee is in the driver's seat with Floyd Headlee in the car. Standing are Ma Davidson (left), Perry Wilson, and Lena Headlee. (Right, USFS; below, FCLHA H06024.)

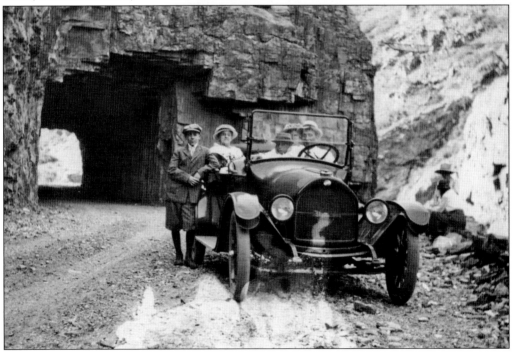

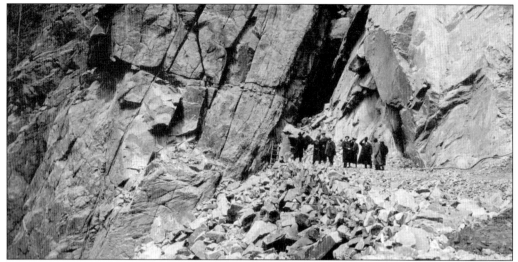

Once the tunnel was completed, there was an easy three- or four-mile stretch before the very difficult Big Narrows section was reached. According to US Forest Service notes on this photograph, the Poudre Valley Good Roads Association met at the Big Narrows in 1916 to determine how to proceed. They decided not to tunnel but to blast enormous quantities of rock to make way for the narrow road. (USFS.)

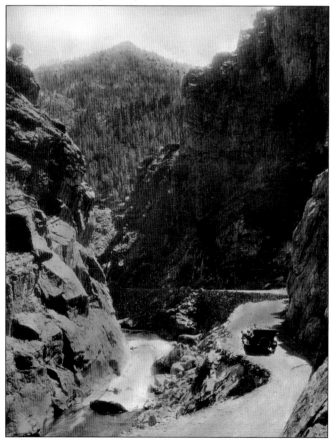

It would take over two years to get through the Big Narrows, but by the end of 1918, a road was in place. Even though the road was passable for cars, it was still very narrow, with cliffs above and the river below. Here, a car makes its way through the Big Narrows, probably sometime in the 1920s. (FCLHA COMT1-35.)

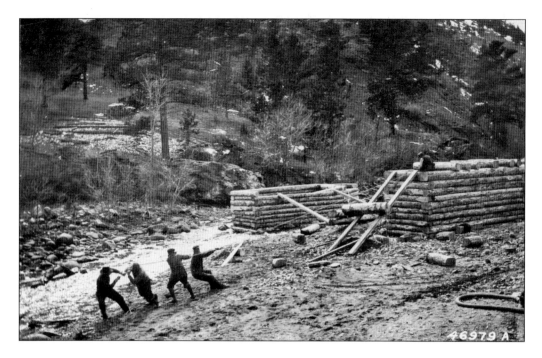

Although today the bridges in the canyon are made of steel and concrete, early bridges were all timber construction. These two photographs show the construction of the bridge at Eggers built in 1921. In the photograph above, a crew of men tugs a log up a ramp for the bridge cribbing. Construction is further along in the photograph below, with decking going on. (Both, USFS.)

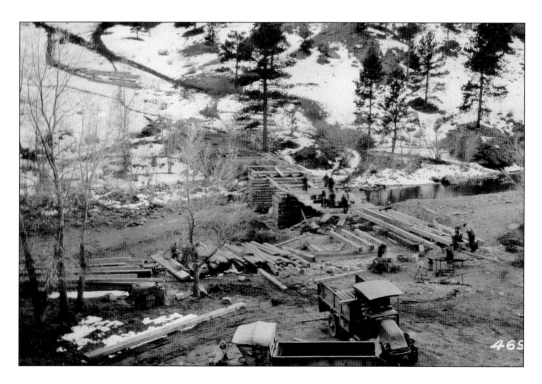

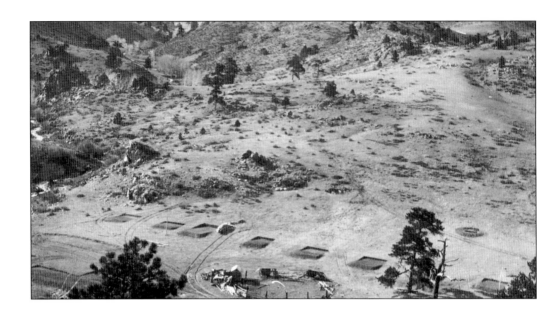

As construction moved along the canyon, the camp for the convicts moved with it. Here are two photographs of the camp when, according to Case, it was located in what is now the Narrows Campground. It was moved to this location shortly after the heavy work was completed in the Big Narrows. The photograph above shows the camp when the tent sites were leveled, and the photograph below shows the tents in place. (Both, USFS.)

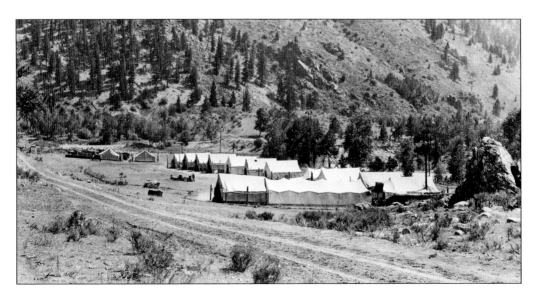

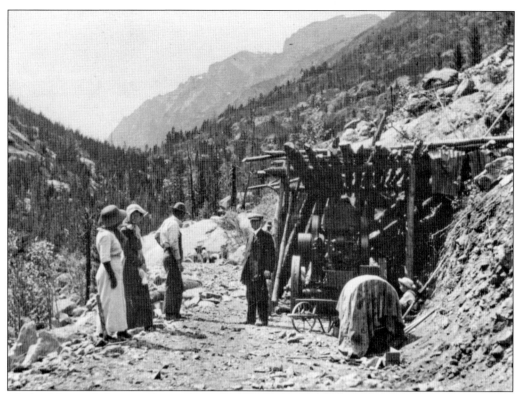

Much of the work done on the roads was backbreaking hard labor, digging, scraping, and hauling dirt and gravel. In this pair of photographs, a small crew uses an air hammer, probably breaking up rocks, while a woman and child look on. The air compressor is housed in the log lean-to. (Above, FCLHA H09426; below, FCLHA H09427.)

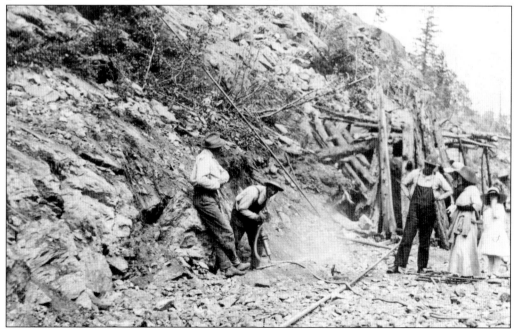

Convicts work on the road in this image. The road could not have been built without the low-cost labor of the convicts, but escapes were an ongoing problem. Most of the escapees ran in May or June, when there were warm months ahead. One convict ran on October 19, 1917. He was found dead on February 22, 1918. Winter is not the best season to hide in the Poudre Canyon. (FCLHA H09428.)

Where possible, tractors were brought in to grade the road and shape the shoulders. Unpaved, it was vulnerable to weather conditions—snow and rain that created ruts and mud—and required frequent maintenance. (USFS.)

A wide variety of equipment was used in the construction of the Poudre Canyon Road. Even though the automobile was fast replacing horse and wagon, horses were still useful at times. In the photograph at right, a horse-drawn wagon hauls and dumps a load of stones. In the photograph below, a steam shovel helps with the labor-intensive work of cutting a road into the side of the hill near Cameron Pass. Behind the steam shovel is an air-compressor tank mounted on a horse-drawn wagon. (Right, FCLHA H09639; below, MEM.)

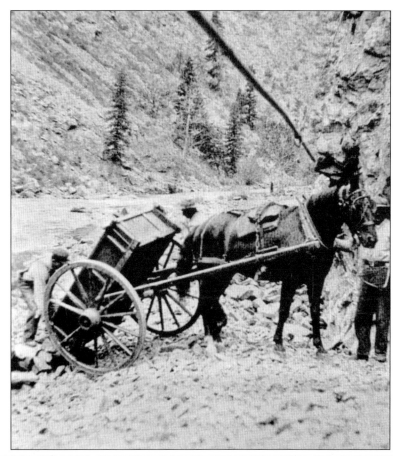

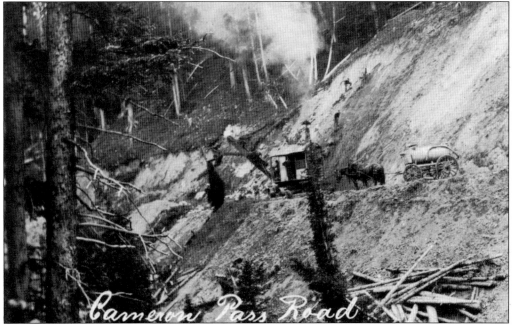

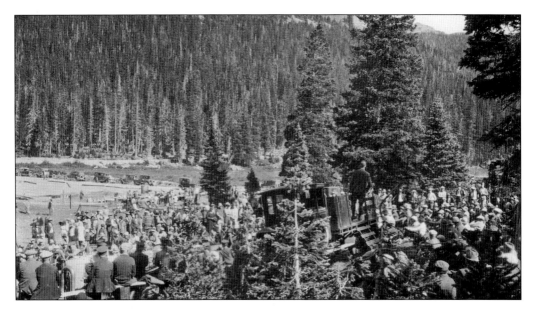

When the road was open all the way to Cameron Pass and connected to the North Park Road in 1926, many people gathered on Labor Day, September 6, 1926, to celebrate the occasion. At last, Poudre Canyon was open from bottom to top and, according to Case, 3,000 people in about 1,000 cars made their way to the pass for a picnic, barbecue, speeches, and entertainment by a Fort Collins band. (Above, USFS; below, FCLHA H20151.)

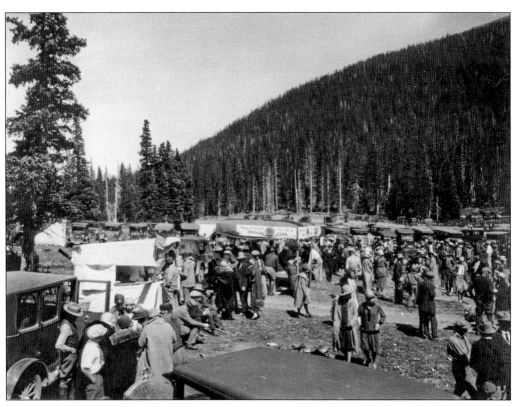

Five
From Ted's Place to Mishawaka

Before the road was completed, it was almost as if the canyon were divided into two different worlds, separated by the formidable Narrows, which had to be circumvented. In the early 1900s, Fort Collins workers were going as far up as what is now Gateway Park to build and maintain the gravity-fed city waterworks in the lower canyon, and one resort, Poudre Canyon Fishing and Summer Resort, was opened by Ed Liggett and J.F. Snook on June 24, 1908, complete with 12 tents, bedding, and a chef.

Mishawaka, which was known then as Thompson's Resort, was a popular stopping place as well a few years later. This chapter features the region from the landmark entrance to the canyon, Ted's Place, at the turnoff onto State Highway 14 from US Highway 287, as far as Mishawaka, which begins chapter 6. Also of note are a Civilian Conservation Corps (CCC) camp, the waterworks, and several resorts that flourished in the first half of the 20th century. The canyon's history unfolds westward along the road.

Many of the resorts and landmarks in the following chapter will be identified using canyon mileposts (MP), from Ted's at MP 121.7 to Cameron Pass at MP 65.0.

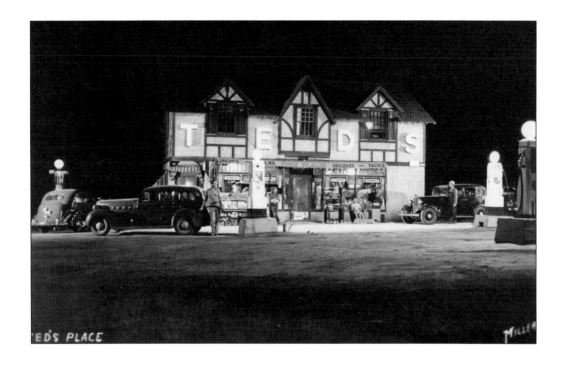

In May 1922, Edward "Ted" Herring opened a filling station and store at the fork of the road to Laramie, Wyoming (now US 287) and the Poudre Canyon Road. Named the Poudre Canyon Filling Station, the popular stop quickly became known as Ted's Place (MP 121.7). The small original store was replaced by the iconic building with the big letters, shown in the top image, in the 1930s. After Herring's death in 1963, at age 70, the business went through a string of owners. By March 1988 it had been seized, as the sign in the window of the lower image shows, for nonpayment of taxes. Despite local support from historians and preservationists, Conoco destroyed the building in 1989, though it lives on as one of the few businesses to earn a place on Colorado maps and is still known to locals as Ted's Place. (Both, MEM.)

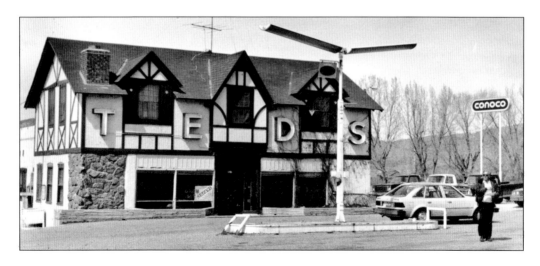

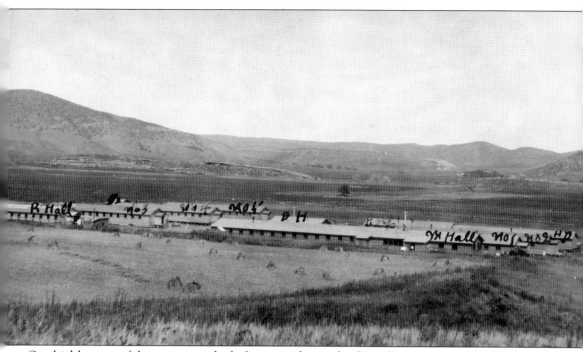

One highly successful governmental relief measure during the Great Depression was the Civilian Conservation Corps (CCC) project, which put thousands of able young men to work. Most of their monthly salaries ($25) supported their families, and the recruits were housed in camps to work on soil conservation, campground construction, reclamation, and many other conservation improvements. This photograph shows a camp in the lower Poudre Canyon during the 1930s. The camps were located in national and state parks and forests all over the United States. (FCLHA H02024.)

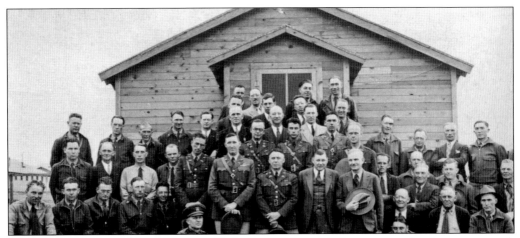

The camps were set up like military establishments and were in fact overseen by Army personnel. Here, a group of camp managers gathers for a photograph. The recruits were provided with housing, food, medical care, and transportation. A true interagency effort, their work aided the US Forest Service, the Soil Conservation Service, the Bureau of Reclamation, and the National Park Service, among others. (FCLHA H05912.)

Recruits gather in front of the Fort Collins Post Office on College Avenue to await transportation to the camp. The US Department of Labor selected the young men who would enter the program and had no lack of potential recruits, even though conditions at the camps—at least in the beginning—were not ideal, with the men being issued World War I–vintage Army clothing and rough wool blankets for sleeping. (USFS.)

Off they go to a mountain camp. In Colorado, many mountain parks began as CCC camps, later taken over by cities or the state. Several parks in Poudre Canyon can claim that distinction. The hard labor the workers put in to create these camps paid off; when World War II began, a large number of the soldiers who lined up to enlist had been CCC recruits, hardened to discipline, hard work, and basic conditions. (USFS.)

A truck delivers stones to a mountain camp CCC project as men stand by to unload and place it. The program was open to young men between 17 and 23 whose families were verifiably in need. They could enroll for six months and stay as long as two years. Each recruit had to fill out an application and go through an interview in order to be accepted. (FCLHA H20025.)

Picnic Rock (MP 119.0) was one of the earliest landmarks in the lower Poudre Canyon. As early as 1887, Picnic Rock is mentioned as a meeting place in the society pages. Romances surely started here; at least one 1880s murder, committed by Jim "Tiger Jim" Wilson, is rumored to have occurred there. These four women standing on the top of Picnic Rock around 1900 certainly represent the placid side of the canyon location. (FCLHA H15971.)

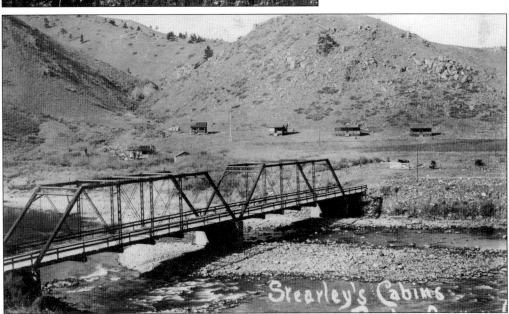

Stearley's Cabins are mentioned by the local newspapers as early as 1911, but this image was probably taken closer to 1920. The cabins were owned and operated by Fred Stearley, a 1903 graduate of Colorado Agricultural College. Now gone, the resort was located on the south side of the river about one mile below Gateway Park. (MEM.)

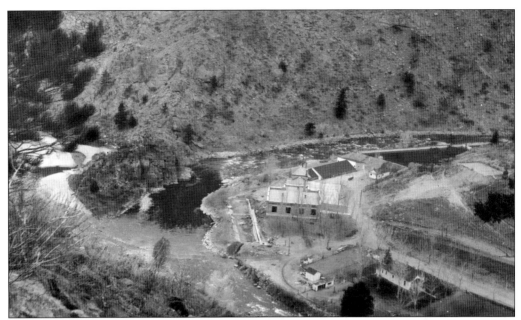

In 1903, Fork Collins residents voted to extend the water supply pipes up the Poudre Canyon. The Waterworks Plant (now Gateway Park) became an early fixture in the lower canyon. According to a local newspaper article, the gravity system was expected to supply the city with enough water to provide "a great plenty for sprinkling lawns at all hours of the day." This photograph shows the plant in the mid-1920s. (FCLHA COMT1-14.)

This image is the first of three that show additions to the plant over time. Herb Alexander was the superintendent from 1942 to 1979. His son Ben Alexander, who grew up there, helped to explain the images. In this image, concrete is being poured on the outer wall of the 1924 sedimentation basin, which uses gravity to remove solids from water. (FCLHA H00519.)

Horses and mules pull scrappers to form the footings and basement for the mid-1920s addition to the plant. The project included six new faster sand filters that used hydraulic power to operate the valves. The original filters were all manually operated, requiring considerable upper-body strength (and sometimes a cheater bar) to operate the valves. The house on the left side of the photograph is where Ben and his parents lived. (FCLHA H19619.)

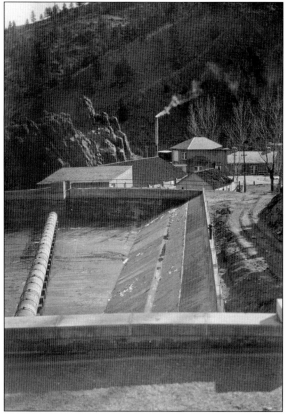

The sedimentation basin in this photograph has been drained, probably for cleaning. Accumulated sediment was periodically washed out with fire hoses. After a spring and summer season, the sediment could often be a foot deep. During the winter, ice was cut off the sedimentation basin and used in the icehouse. (FCLHA H19655.)

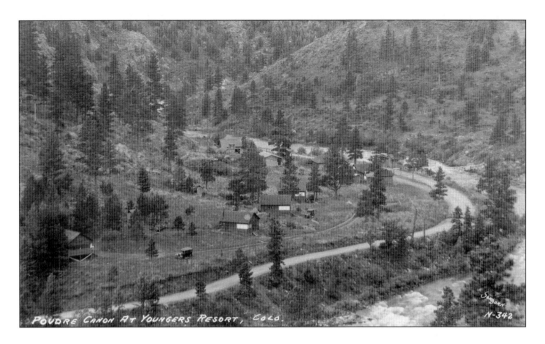

Years before the convict-built road reached the area, Alvi and Louis Yauger homesteaded at about MP 113, which they accessed via the Rist Canyon road; awhile later, Yauger relocated his ranch a few miles up the road, and the couple opened Yauger's Resort sometime between 1915 and 1920, according to author Stanley Case. Fort Collins residents would often drive to the resort just for their homemade ice cream. Below is the suspension bridge Yauger built across the river to feed the trout, which would come when he whistled. The couple leased out the business when Yauger's health began to fail in 1939, and some years later, both structures burned to the ground. (Above, Wayne Sundberg; below, MEM.)

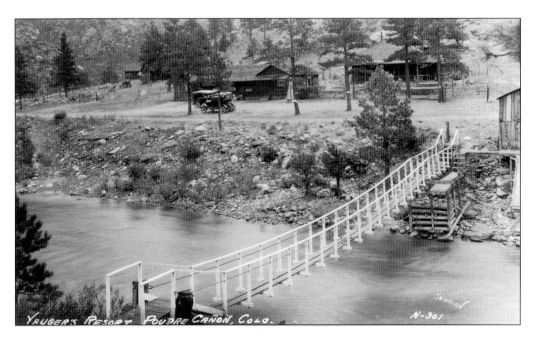

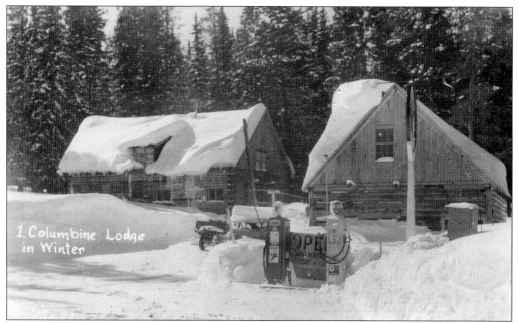

This resort (MP 112.0) began as Columbine Camp in the late 1920s, with a grocery store, five cabins, a campground, and a pony ring. It was started by Archie Jordan, a Fort Collins grocer, and has had a long string of owners over the years. Columbine is still in business but now under the name Columbine Lodge and Rusty Buffalo Campground. This winter photograph is postmarked 1963. (MEM.)

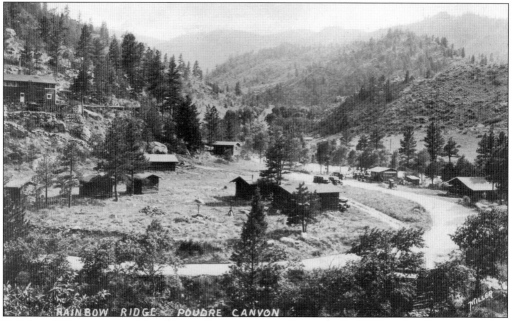

Rainbow Ridge, a resort with cabins and a store, opened in the early 1940s under the management of Pete and Mary Townsend. These resorts were popular summer stopping places for locals, who liked to buy refreshments along the way, and they enticed tourists who liked to fish as well. (Wayne Sundberg.)

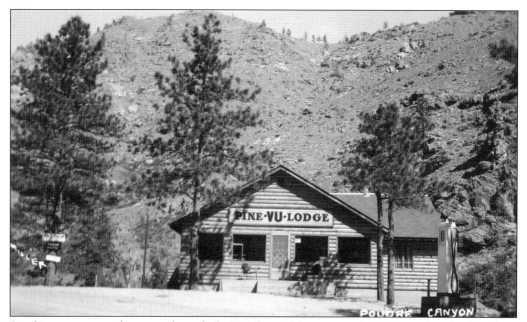

Road improvements that went through the Rainbow Ridge property in 1947 put an end to Rainbow Ridge. The site was purchased by Gordon and Idella McMillan, who built a new main building and reopened the resort as Pine View Lodge. Sometime later the name became Pine Vu Lodge. The resort was open until it burned down in 1991. (MEM.)

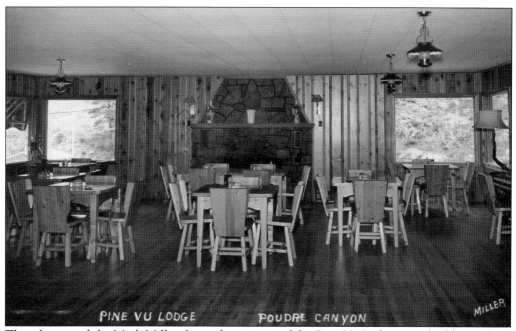

This photograph by Mark Miller shows the interior of the Pine Vu Lodge main building, which housed a cozy restaurant and offered a fine view from its large windows. (MEM.)

On May 27, 1918, the US Forest Service granted the City of Fort Collins a special-use permit for land in the Young's Gulch area to use as a mountain park. As part of the back-to-nature movement, Colorado towns were looking for outdoor recreation areas; Fort Collins now had its park. After a 1910 forest fire in the area, 10,000 trees were planted there in the spring of 1919—a pine plantation. The photograph above shows growth some 15 or 20 years after the planting. The park was named after Ansel Watrous, pictured at left, an early newspaper editor who, in 1894 at the age of 83, traveled through Rist Canyon and hiked down Young's Gulch to fish the Poudre River. After the permit expired, the US Forest Service continued to maintain a campground in the area (MP 108.7), which still bears Watrous's name. (Above, FCLHA H03642; left, FCLHA H06653.)

Six
MISHAWAKA TO RUSTIC

Today, Mishawaka (known to locals as the Mish) is a widely known, popular music venue, having gone through several iterations over the years to become what it is today. As one travels west up the canyon from that point, the crucial Narrows appear, which for so long inhibited connecting the upper and lower canyon. After going through the tunnel at the Little Narrows, one passes former homesteads, resorts, and a school and then comes to the Big Narrows, where the decision was made to blast rather than tunnel through the rock.

Some of the conservation work undertaken by CCC workers can be seen as well as the small settlement of Eggers, where there was a school, and Indian Meadows, on the way to Rustic.

US Forest Service campgrounds are a big draw to the canyon. There are 12 campgrounds along Highway 14; five of them, including the largest, Mountain Park, are in this section.

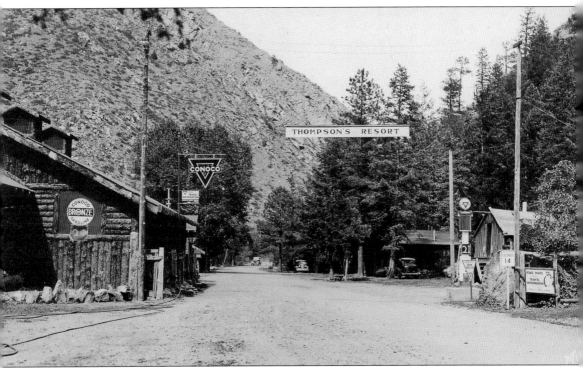

Walter S. Thompson was a traveling piano tuner from Denver who was visiting Fort Collins as early as 1901 for his work. In 1907, he bought Woods Music on South College Avenue and moved to Fort Collins with his family. On a motorcycle trip through the canyon in 1916, he fell in love with a site along the river. It would take a few years, but by 1920 Thompson's Resort was running. Thompson called the resort Mishawaka, after a town he knew in Indiana, while locals called it Thompson's Resort. Apparently, by the time this photograph was taken around 1935, Thompson had decided his customers were right. (MEM.)

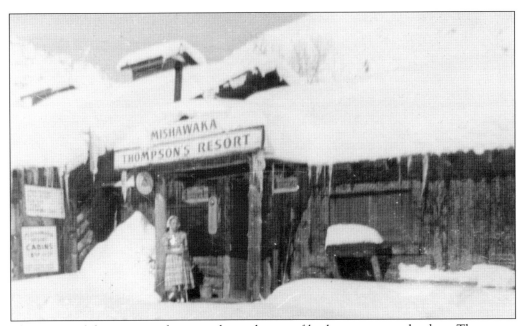

This image of the resort in the snow shows the use of both names over the door. The resort, located at MP 108, had six cabins and a store, and on May 29, 1920, a new dance pavilion opened, offering dances every Wednesday and Saturday. The Thompson family provided music for all the dances. (FCLHA H20833.)

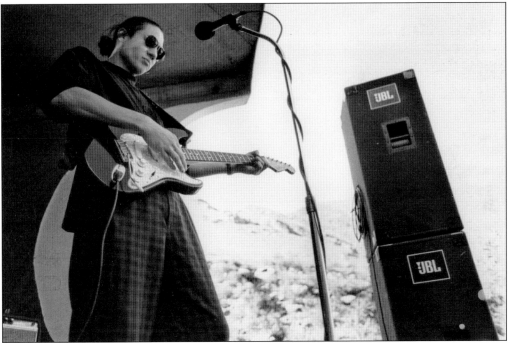

In the mid-1950s, Thompson began to have health problems and sold the business. A string of owners followed over the years. Now, with an outdoor amphitheater instead of rental cabins, the Mish is a premier outdoor music venue, hosting groups such as Big Head Todd and the Monsters, shown here in 1992. (FCLHA H23342.)

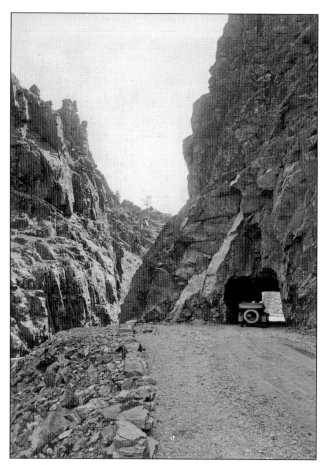

As the contrast between these images clearly shows, the Little Narrows tunnel (MP 107.3) was widened at least once. The photograph above shows dramatically how narrow the canyon is at that point. The height of the rock through which the tunnel was blasted is formidable as well; it is easy to see why the canyon was divided for so long and why it was so challenging to open up the road all the way through. (Both, MEM.)

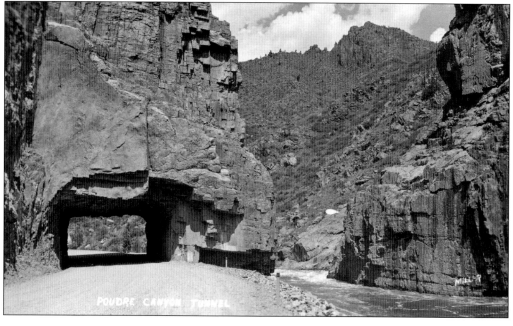

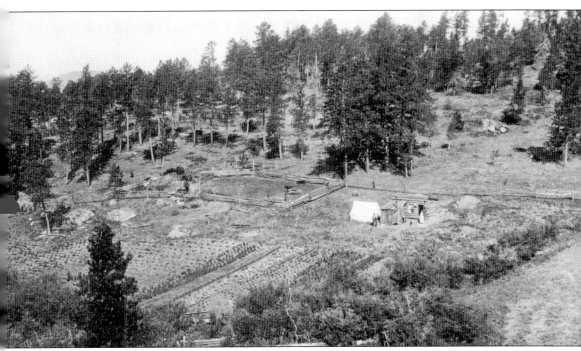

About 1.5 miles west of the tunnel, Stove Prairie Road comes in from the south. For decades, this road was the only access to the short, relatively flat area between the Little and Big Narrows. The *Fort Collins Courier* ran a story in 1878 describing a trip through Rist Canyon and down Stove Prairie Road to fish in the Poudre River. The trip required an overnight stop at a Stove Prairie ranch and climbing a hill so steep that it took a team of four horses to pull their wagon up, while the fisherman walked. But by dinnertime they had caught enough trout for a fine meal. Ranching got an early start in the Stove Prairie area, as demonstrated by this great photograph of the Tom and Mollie Morgan homestead, captured around 1887. Based on the number of times Tom Morgan is mentioned in early local newspapers, he must have made the trip to Fort Collins frequently. (FCLHA H02462.)

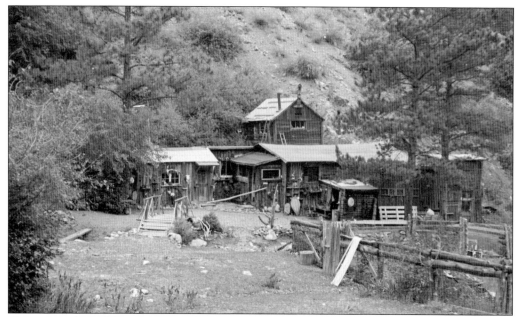

Turning south on Stove Prairie Road, one comes to Skin Gulch, where this cabin, owned by John "Rattlesnake Jack" Brinkhoff and his wife, Polly, once stood. The cabin expanded as need and materials dictated. After Jack's death, Polly entered into an informal arrangement with the US Forest Service, allowing her to live in the cabin on federal land. When she died around 1999, her children honored the arrangement and burned the house to the ground. (FCLHA T02836d.)

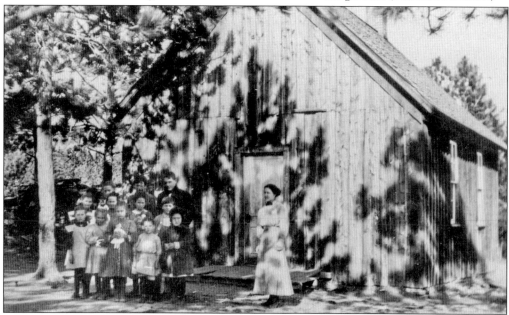

About five miles south, on the west side of Stove Prairie Road, is the historic Stove Prairie School. It opened in 1896 and is the oldest operating one-room schoolhouse in Colorado. Even when this photograph was taken in February 1912, there were only 12 students and a single teacher, unfortunately none of them named. The 2012 High Park Fire threatened the school, but good fortune and the fire department kept it safe. (FCLHA H03208.)

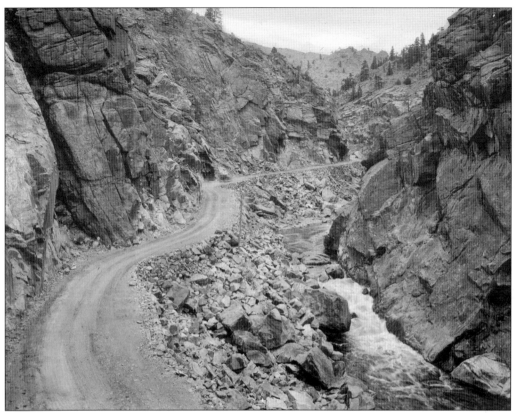

Farther west up the canyon, the Big Narrows presented another mammoth obstacle. Here, engineers decided to dynamite the rock away rather than blasting a tunnel through it. Without such blasting, the road could not have been built, for the canyon is extremely narrow at this point. (Above, FCLHA COMT1-33; right, MEM.)

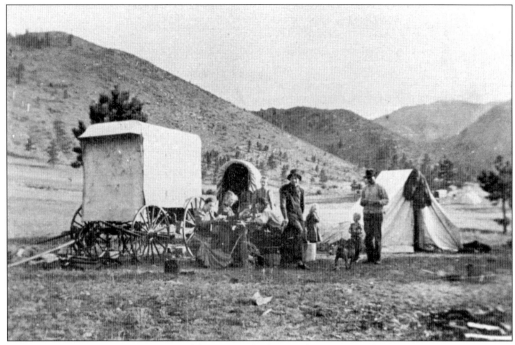

At the Dutch George Campground (MP 100.6), the Poudre River makes a big loop to the north and partially encloses an area of rolling meadows know as Dutch George Flats. Dutch George was the nickname for George Werre, an old-time trapper and hunter who, according to a November 23, 1878, letter to the editor, died when a bear Werre thought he had killed, "raised up and killed him." This area has long been a favorite place for camping as testified to by the top image of an early family outing at Dutch George's. Even in 1906, it was not easy to get to Dutch George Flats. Looking at the lower image, captioned "Road to Dutch George's," certainly begs the question, "What road?" (Above, FCLHA H02755; below, FCLHA H08561.)

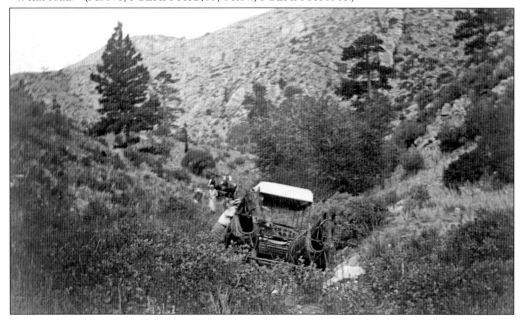

Mountain Park, which began as a CCC camp, was established in 1935 by the City of Fort Collins. Located 40 miles from town, it was popular with locals and featured privies, picnic tables, and trails, along with a community house and a playground for children. At top, CCC workers prepare to plant trees to enhance the beauty of the park; below, they work on the shelter house. (Both, USFS.)

Above, the sign welcoming visitors to Mountain Park campground is visible at lower left. CCC workers constructed the bridge across the river. At the bottom is an early photograph of the completed park. The park is still a favorite with locals and tourists alike, as it features numerous spaces for tents and is near the McConnell Trail, named for R.C. McConnell, one of the earliest park rangers in Roosevelt National Forest, and the Kreutzer Trail, named for William Kreutzer, considered the first official US forest ranger in the country. (Above, FCLHA H24929; below, USFS.)

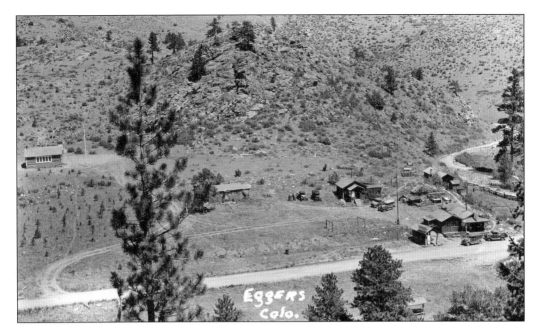

In 1921, work started on a bridge and a road from the Poudre Canyon Road to the college's new Pingree Park campus (see chapter 9). Recognizing the business opportunity the junction provided, Fred and Alma Eggers applied for and received a US Forest Service lease to start building the little town of Eggers, Colorado. By 1922, construction was underway on the south side of the bridge at what is now about MP 96. The two views of Eggers on this page are both from a mid-1930s postcard. The views show the store/post office and gas station in the far right foreground (and in the close-up), a couple of private homes in the center, and the Eggers School on the far-left edge. (Both, MEM.)

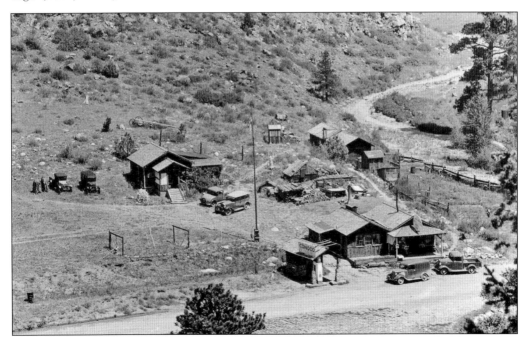

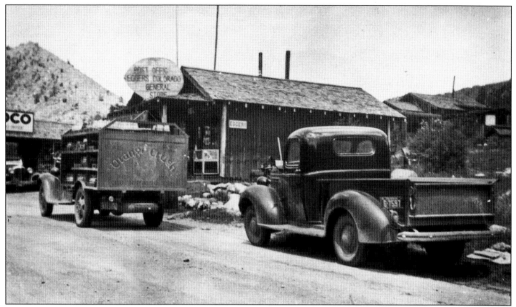

Pictured here in the 1940s is the Eggers Post Office and general store. According to Case, the Eggers Post Office opened on April 23, 1926, and closed April 30, 1944. (FCLHA H08361.)

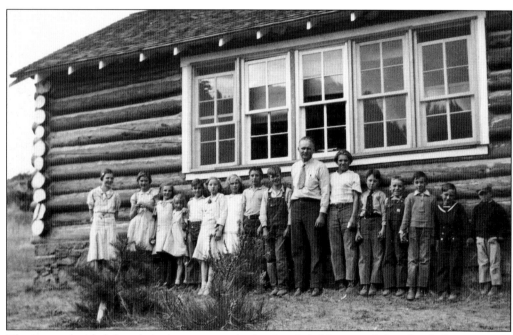

The Eggers decided that their three sons and other local children needed a school. Construction of the school was a 1933 Works Progress Administration (WPA) project. While the CCC employed young men, the WPA employed older out-of-work men on public-works projects. This 1937 photograph shows a large class with two unidentified teachers. Closed in 1959, the building was moved near the Poudre Canyon Chapel and is today a museum of canyon history. (FCLHA H22639.)

Eggers apparently had a free campground at one time, indicated by the photograph above. There are also photographs of CCC workers building an incinerator at the Eggers camp. One of the CCC series is shown here. Case says all the Eggers buildings but the schoolhouse were gone by 1951, leaving only foundations. (Above, FCLHA H00186; below, USFS.)

Christian Rugh, a native of Pennsylvania, came to Fort Collins in 1887 with his wife, Jennie, and their son. They opened a mercantile in Fort Collins and a wholesale business in Greeley before establishing their Poudre Canyon resort, shown here, in 1893. Rugh acquired the property to satisfy a $500 debt and quickly turned it into a favored spot for fishing and conviviality, with a nightly campfire and fried trout. (MEM.)

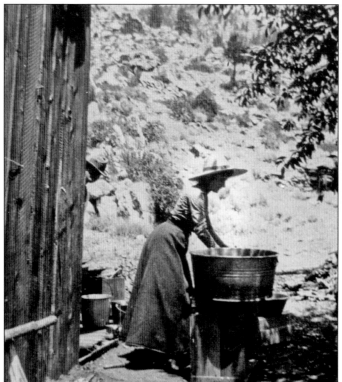

The Rughs' son, Blair, named the main cabin Idlewylde, which soon was used to refer to the whole resort. Here Rugh's granddaughter Stella Rugh Drury does laundry near the homestead cabin. Washing clothes was a challenging task—heating water, submerging the clothes, rinsing them, wringing them, and hanging them up to dry. (FCLHA H09637.)

Not only did fishermen and campers enjoy the ranch's amenities, but so, it seems, did deer. Here, two quite tame deer take treats from the hand of a man believed to be Christian Rugh. After the Rughs' deaths, the land was eventually divided into individual lots on which some had cabins, others stores. (FCLHA H24916.)

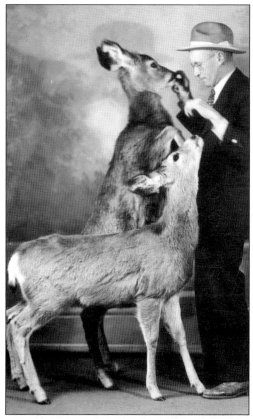

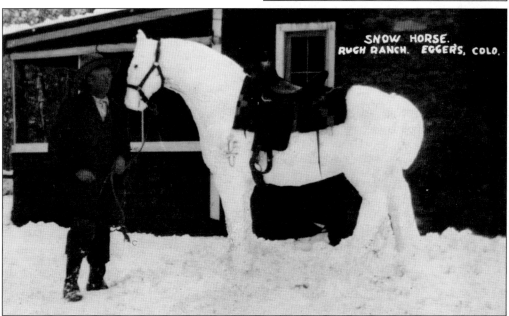

Equipped with saddle blanket, saddle, and reins, this snow horse is a testament to the enduring winter cold in the canyon. The date and man holding the reins are unidentified, but the horse is deftly sculptured. (FCLHA H24919.)

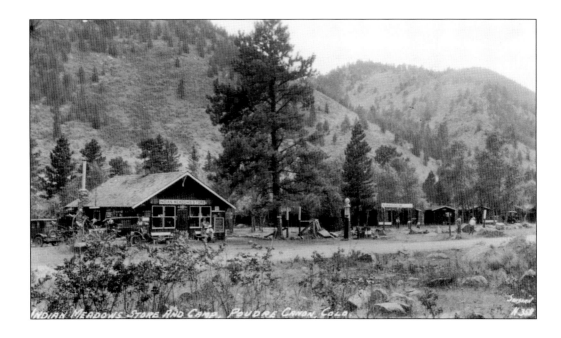

Indian Meadows Lodge (MP 92.6) began in 1926 as a store, with living quarters in the back and a few small cabins. Motorists could purchase gas along with engine oil, fan belts, and other minor-repair automobile parts. Above is an image of Indian Meadows from the 1920s. The image below shows the cabins around 1950. Today, the resort attracts tourists as well as special events such as weddings, along the banks of the river. (Both, MEM.)

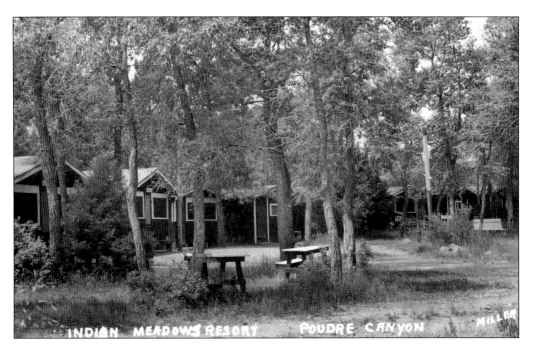

Seven
Rustic to Kinikinik

As one continues westward, the next stretch, between Rustic and Kinikinik, meanders past the sites of several once-popular resorts. This area was for many years favored by larger establishments, which flourished around the turn of the 20th century and for a few decades beyond, experiencing the transition from horse-drawn transportation to motorized vehicles. Rustic, Glen Echo, Arrowhead Lodge, and Keystone Resort all brought tourists and sports enthusiasts into the canyon to enjoy the scenery and amenities. Arrowhead Lodge, used today as a forest service–information center, looks much as it did in its heyday. History unfolds along the way.

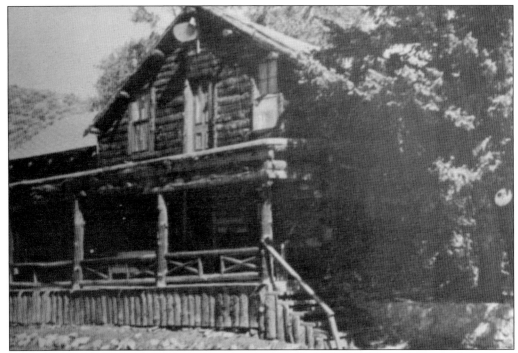

Samuel Stewart built the original Rustic House (MP 90.9) in 1881 for the travelers using his canyon toll road, but in 1885 he lost the property for back taxes. Following a multitude of owners, Will and Alice Richardson bought the building in 1931. The couple made many repairs to the rundown structures, including facing the building with log slabs. This image from around 1935 illustrates why the hotel became known as the "old log hotel." (FCLHA H01289.)

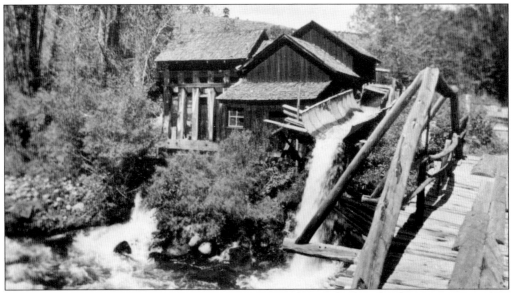

An even earlier owner of the Rustic was Norman Haskins, who bought the property in 1910. His tenure as owner is mostly remembered for bringing electricity to the resort. According to Case, Haskins spent $5,000 to build and equip this power house that used river water to generate electricity. (FCLHA H07933.)

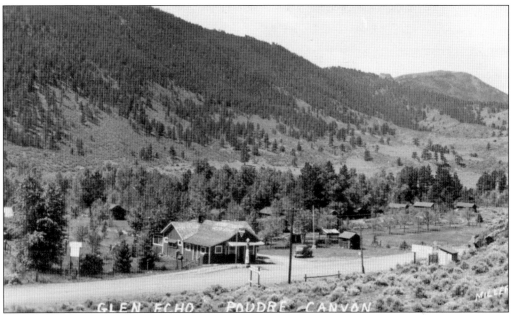

Glen Echo (MP 90.9), on land which once belonged to pioneer settler Norman Fry, was for a time headquarters for a mining and milling operation. Purchased in 1921 by John and Carrie Cook and H.L. and Edith Harris, after the headquarters building had burned down, it soon housed a small store. According to Case, the original store building was hauled across the road by two teams of horses. (MEM.)

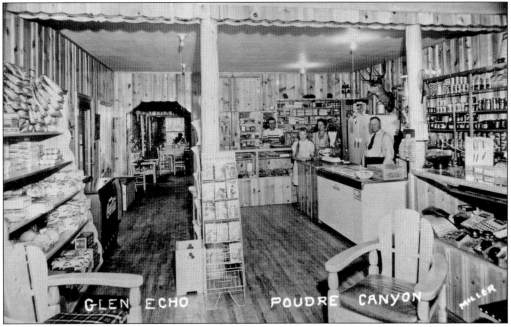

This Mark Miller photograph shows the interior of the Glen Echo store, around 1950. The original store failed during the Great Depression, after which it changed ownership several times. In April 2003, the main building burned down; it was replaced a few years later and now offers a restaurant, store, cabins, and campsites. (MEM.)

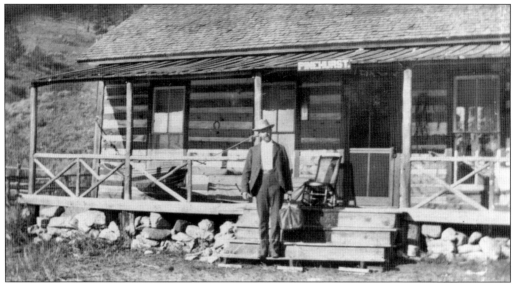

Across the road from present-day Poudre Canyon Chapel (MP 88.8), a popular venue for mountain weddings, Pinehurst was purchased by Fort Collins pharmacist A.W. Scott in 1893, though he did not receive clear title to it until the end of 1895. By 1899, local newspaper society columns were reporting weekly visits to Pinehurst by everyone who was someone in Fort Collins. This image shows Scott at Pinehurst around 1900. (FCLHA H11760.)

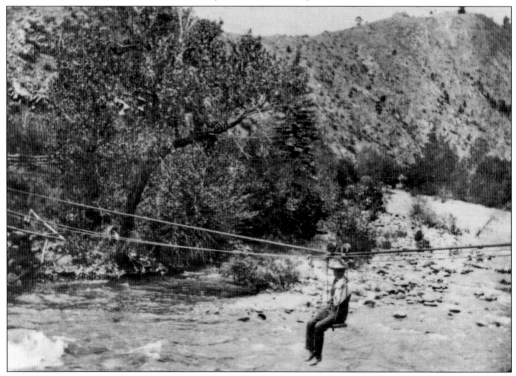

Though there is some confusion as to whether the 1891 or 1904 Chambers Lake flood washed out the bridge, for a while a cable crossing and then a footbridge provided the only access to the property, where the Scotts enjoyed entertaining guests. (FCLHA H10958.)

One of the most famous landmarks in Poudre Canyon is Profile Rock (MP 88.3), labeled by Maud Fry "the old man's face," which was once used as a navigation point. Near Arrowhead Lodge, it gives the appearance of a dignified gentleman overlooking the river as it flows by, with a slightly different profile from each direction. (FCLHA H08423.)

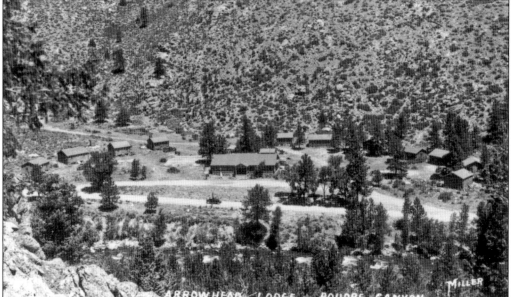

Arrowhead Lodge (MP 87.8) began as a tourist resort, built in 1929 by Carl Brafford and opening for business in about 1936, according to Case. Behind the main building were five cabins, each named for a Native American tribe. The cabins, set in a semicircle, were made of logs brought down from a mill at Chambers Lake. Lola and Stanley Case bought the resort in 1946 when he returned from service in World War II. (FCLHA H11795.)

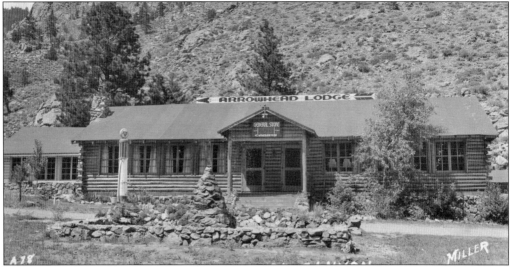

The Cases added one more cabin, Pawnee, to the semicircle and opened for business in May 1946, offering lodging, merchandise, lunch, and gasoline. The lodge quickly became a community center, the site of pancake breakfasts, dances, church services, movies, pie socials, and even talent shows. Many guests came back to the same cabins year after year. The Cases' three daughters helped out with the store and cabins. (MEM.)

With retirement looming, the Cases prepared to sell the property to the forest service but were dismayed to learn that the buildings would be torn down. A concerted campaign by Friends of Arrowhead Lodge and Conservers of Nature Society, with help from Elyse Bliss, led to listing in the National Register of Historic Places, preserving the buildings for use as a US Forest Service information center. A June 1993 gathering celebrated the historic designation. (FCLHA T00536.)

John Zimmerman's Keystone Hotel (MP 84.5) was the premier resort in the canyon for decades. The hotel was started in the mid-1890s and built with bricks made on site. The *Fort Collins Courier* announced its completion on July 22, 1897, calling the setting "one of the most picturesque locations imaginable . . . surrounded by some of the wildest and grandest of mountain views in the world." The building itself was huge for the canyon, three stories, 35 by 66 feet, with 16 bedrooms, a billiard hall, a barbershop, and other amenities. The covered front porch soon became a gathering place for guests. (Above, FCLHA H04532; below, FCLHA H12163.)

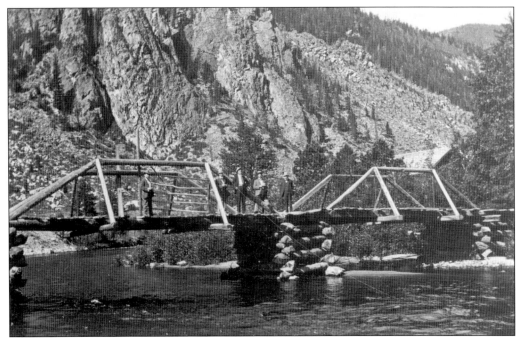

John Zimmerman's son Casper supervised construction of this bridge across the Poudre River. It was completed around 1890, allowing the Zimmermans to start construction on the future resort. Sturdier structures would take its place, but certainly this was the most charming. (FCLHA H09815.)

According to the March 20, 1907, edition of the *Fort Collins Courier*, this huge mountain lion had killed one of John Zimmerman's colts. Setting a spring trap, Zimmerman found the beast with one foot secure in its jaws. After numerous attempts, he was able to drag the animal into a position where his daughter Eda could take this photograph. The lion was killed and mounted, some skeptics think before the photograph was taken. (MEM.)

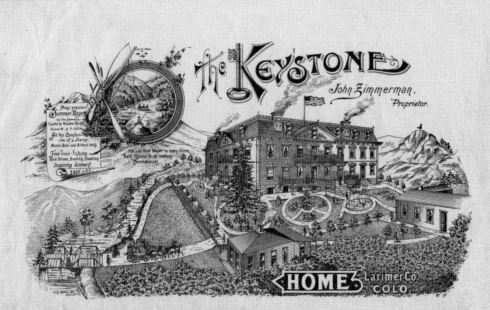

One of the Most Famous Summer Resorts of the West.

Situated 55 miles west of Fort Collins, 7,500 feet above sea level, in one of the most beautiful spots in the Rocky Mountain region, through which flows the Cache la Poudre river. Here can be found beautiful drives, excellent trout fishing and a hotel with all modern conveniences—large, airy, well furnished rooms, with both hot and cold water, bath rooms, etc. To reach this point a review of the following gives full information:

ZIMMERMAN'S STAGE LINE It has been decided to run the line the entire year, winter and summer, between Fort Collins and Keystone hotel. Better accommodations and better rates will be given than heretofore.

DISTANCES AND RATES.

Fort Collins to	Laporte—5⅝ miles............	$.35
" "	Bellvue—9 miles.............	.50
" "	Owl Canon—18 miles........	.75
" "	Forks Hotel—21 miles.......	1.00
" "	Livermore—23 miles........	1.00
" "	Horsley's—24 miles.........	1.25
" "	Chas. Brown's—24½ miles...	1.25
" "	Chas. Emerson's—25½ miles.	1.25
" "	H. C. Brown's—26½ miles...	1.25
" "	McNey's—30 miles..........	1.50
" "	J. S. Sloan's—34 miles......	1.50
" "	S. Batterson's—35 miles.....	1.75
" "	P. J. Olsen's—36 miles......	1.75
" "	J. H. Sargisson's—39 miles..	2.00
" "	Forks of road, Laramie river—40 miles...............	2.00
Fort Collins to	Zimmermans' stage barn—41 miles.....................	$2.00
" "	John Pierce's—42 miles......	2.25
" "	Will Batterson's—43 miles...	2.25
" "	D. F. Robinson's—43½ miles.	2.25
" "	Clark Goodell's—44 miles....	2.50
" "	Manhattan—45 miles........	2.50
" "	Rustic—48 miles............	2.75
" "	Keystone—55 miles.........	3.00

BAGGAGE, ETC.—Trunks, 50c extra; excess baggage, 75 lbs. allowed; express matter, from Fort Collins to Livermore, 10c to 25c; per package through to end of route, 25c. Freight through, 75c to $1.00.

Office at Commercial Hotel. All orders left there will receive prompt attention. Leave Collins 6.45 A. M. and arrive at Home 6.30 P. M. Leave Home 6.45 A. M. and arrive at Collins 5.30 P. M.
CASPER ZIMMERMAN, Manager.

Rates, 8, 10, 12 and $14 Per Week. For Particulars write JOHN ZIMMERMAN, HOME, COLORADO.

A flow of guests, both summer and winter, was necessary to keep the large hotel in business. Advertising and transportation were required. This early flyer advertises both the hotel and the Zimmerman Stage. Within one month of opening the resort, Zimmerman was running a twice-a-week stage from Fort Collins to the Keystone Hotel. By the summer of 1899, the stage ran daily, carrying passengers to the hotel and mail to the Home, Colorado, post office, now located at the resort. As one can see from the flyer, it took almost 12 hours to make the trip from Fort Collins to the Keystone and cost $3. (FCLHA.)

After the Keystone Resort finally closed, despite Agnes Zimmerman's desperate attempts to keep it going, the land was acquired by the Colorado Department of Game and Fish, now the Colorado Division of Wildlife. The purchase included all of the resort buildings along with John Zimmerman's reservoir and fishponds. The hotel was razed in the summer of 1946. Today, a fish-rearing operation provides stock for several Colorado waterways. Visitors are welcome at the ponds (MP 83.8) without fishing poles, of course, or the family dog. Below, a group of tourists watches a ranger demonstrate part of the rearing process. Hatchlings are delivered to the ponds to be fed a carefully controlled diet until fully grown and ready for transport to a lake or river—where fishing poles are welcome. (Above, FCLHA H02309; below, FCLHA H05174.)

Eight

KINIKINIK TO CAMERON PASS

In the upper canyon, the air is crisper—and colder in winter—and the resorts farther apart. One early establishment, Sportsman's Lodge, still thrives, but others are long gone. Water is the real story here: ditches and tunnels move water to the Poudre River basin from other watersheds and reservoirs store the precious spring runoff until needed later in the year. This chapter stops by some historic resort sites, visits Chambers Lake, takes detours to Long Draw Reservoir, the Laramie-Poudre tunnel, and Grand Ditch, and finally arrives at Cameron Pass, elevation 10,276 feet, on the border between Larimer and Jackson Counties and only three miles from the northern boundary of Rocky Mountain National Park. Arrival at the pass, said to have been discovered by Robert Cameron, ends the journey along the Poudre Canyon Road.

Charles "Cap" Williams opened Kinikinik Resort, consisting of a store, gas station, and a few cabins, sometime in the mid-1920s, on the south side of the canyon road near MP 81.8. Williams ran the operation until he died in 1940. At one point, Williams had much grander ideas: Case found an architect's sketch of the Roaring Forks Hotel, a 150-room dream that never materialized, in a promotional advertisement produced by Williams in 1915. (MEM.)

One of the most identifiable rock formations in the canyon is Sleeping Elephant Mountain, located across the road from the Sleeping Elephant Campground (MP79.0). One can easily pick out the trunk and ears of the reclining elephant that rises 1,300 feet above the valley floor. (MEM.)

Known today as Sportsman's Lodge (MP 78.5), this resort opened as Gladstone Cottages sometime in the early 1930s. Bryson and Mabel Gladstone built the store, which included their living quarters, and five cabins. They rented the cabins and served family-style meals until they sold the property in 1946. (MEM.)

William and Clara Schoeman bought and expanded the property and changed its name to Sportsman's Lodge. They owned and ran it until September 1956. This photograph of the interior of the lodge probably was taken during their tenure. (MEM.)

Paying $1.25 per acre, Alfred Willard filed for a 40-acre homestead between Stewart's toll road and the river in 1903. Willard did not last long as a homesteader in the canyon, though, selling the land in about six months. After the property changed owners several times in the interim, in 1919 new owners platted the Spencer Heights subdivision of 31 lots. Until the US Forest Service purchased the land decades later, the Spencer Heights store served travelers. The store is no longer there. (Above, FCLHA M00340.5A; below, FCLHA M00340B.)

This photograph shows the survey crew for the Laramie-Poudre Tunnel, a water diversion project started around 1907 and one of several such projects built to bring water to farmers in the Northern Colorado Front Range. A graduate of Colorado Agricultural College, county engineer Emmett McAnnelly (right) supervises the activity. Their survey was so precise that when drilling crews met in the middle of the tunnel, there was less than one inch of error. (FCLHA H07840.)

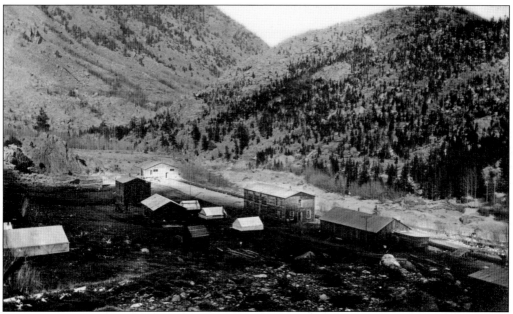

The workers' camp set up to house, feed, and care for the tunnel workers appears in this photograph. The camp included bunkhouses, a commissary, and even a small hospital. The tunnel was a massive project about 2.5 miles long and costing around $300,000. The system moved water from the Laramie River through the tunnel and into the Poudre River about 1.5 miles below Poudre Falls. (MEM.)

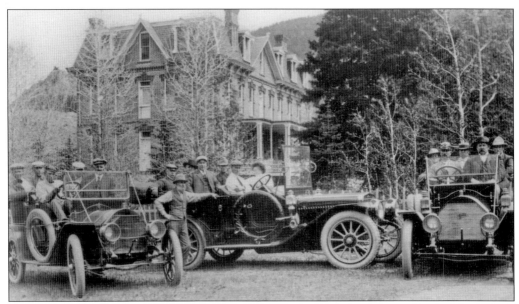

The Keystone Hotel, above, was the site of a celebration when the Laramie-Poudre Tunnel was completed in 1911. Since the canyon road was not yet open from end to end, drivers had to get to the resort via Livermore, maneuvering their vehicles along the narrow dirt roads. Below, the celebrants gather at the tunnel itself, no doubt impressed by the feat of engineering and thankful for the additional water it would bring to the Front Range. (Above, FCLHA H11390; below, FCLHA H02964.)

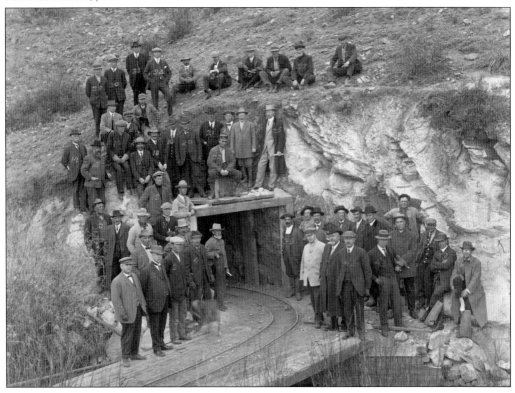

The Chambers Lake area once drained into the Laramie River. Thousands of years ago, a landslide changed the landscape, forming a small lake that now drained to the Poudre River. As early as 1887, Chambers Lake was deepened and a 10-foot-high earthen dam built to hold more irrigation water. Bigger and better dams would follow, but Chambers Lake was on its way to becoming a recreational jewel along the canyon road. (MEM.)

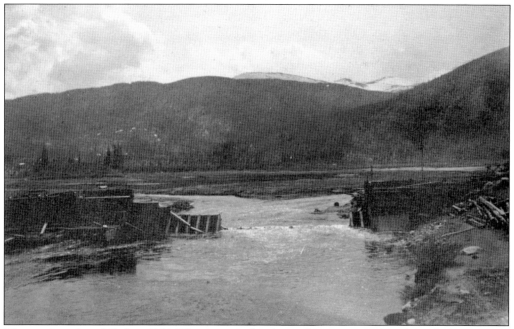

The earthen dam failed in 1891. The ensuing flood wiped out trees and bridges all the way into Fort Collins. A new 12-foot dam, reinforced with log piles and cribbing, almost immediately took its place. It failed in 1904. The damage is shown in this photograph taken shortly after the break. (FCLHA H02874.)

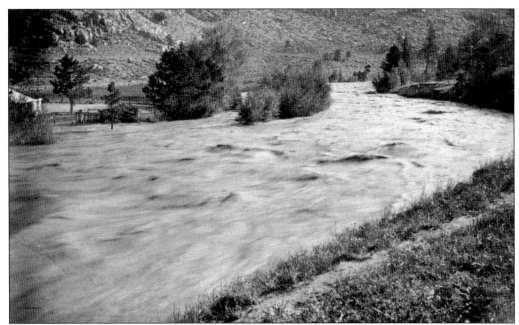

A May 25, 1904, *Fort Collins Courier* article reported on the "terrific rain storm [that] raged in the mountains . . . west of Fort Collins," and the immense volume of water flowing in the Poudre River, as this photograph, probably taken near town, shows. The article concluded that the break in the dam was not a significant factor in the flood that caused over $1 million in damage in the valley. (FCLHA H02875.)

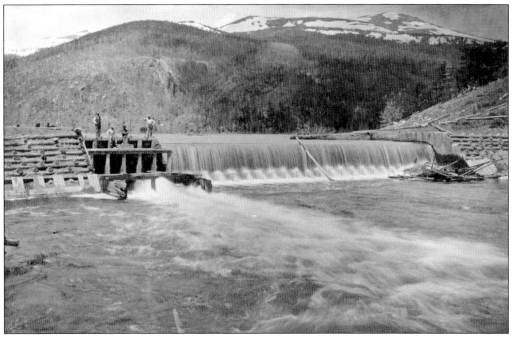

A more modern, safer dam, with a concrete spillway, was under construction in 1910. This photograph probably celebrates completion of the work. A section of log construction at the far left side of the name is a remnant of the earlier dam. (FCLHA H07706.)

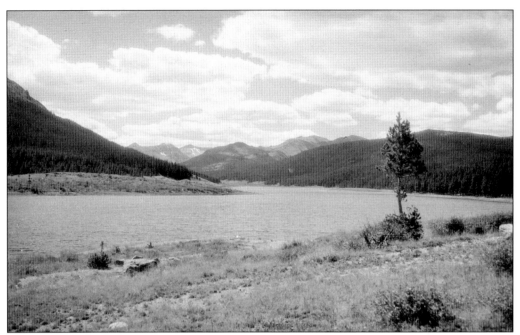

Long Draw Reservoir, above, was constructed between 1927 and 1930 after an agreement was reached with Congress to allow water to fill land located within Rocky Mountain National Park. With the land in question transferred from the National Park Service to the US Forest Service, the project could go forward. La Poudre Pass Creek was dammed to create the reservoir, which was due to be enlarged in the future. According to Case, one of the steam shovels used to build the dam became mired in mud and was left in place until finally cut up for scrap metal decades later. Below, in 1948, campers settle in at the campground and picnic area that accompanied the new body of water. Enlargement finally happened in 1974, and maintenance has continued. (Above, FCLHA Ha3788-1; below, FCLHA Ha3779.)

Cameron Pass was named for Robert Cameron, a Union veteran and a founder of the agricultural colony that became Fort Collins. The pass, at MP 65.0, marks the unofficial end of the Poudre Canyon Road, though Colorado 14 continues on to Walden, Colorado. Visitors at the pass can find the monument shown here, as well as several hiking trails. Cross-country skiing in the area is also popular today. (MEM.)

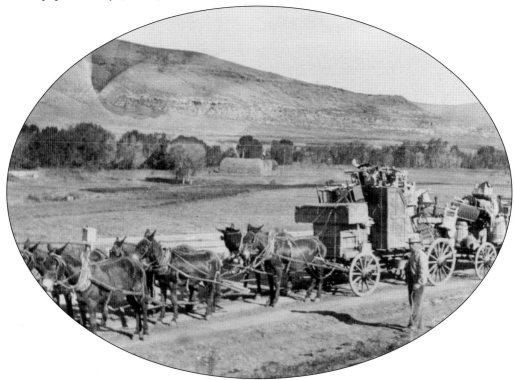

Water quickly became a big issue for front-range farmers and ranchers. Reservoirs provided a way to store water that would otherwise have been wasted, but more water was needed, especially in low-water years. Ditches were the answer, moving water from other watersheds to the Poudre River. The Skyline Ditch was one of the earliest. Here, a six-mule team pulls a tandem load of material to the Skyline camp near Chambers Lake, in 1891. (Rene Lee.)

The Skyline Ditch diverts Laramie River water into Chambers Lake. Construction of the five-mile ditch started in 1891 and required a 100-foot tunnel through solid rock and a 400-foot wooden flume over a deep depression. The seasons were short and the work manual, but by 1894, water was being diverted into Chambers Lake. There was national interest in the project. *Harper's Weekly* ran an article on the Skyline Ditch on June 12, 1897. It included photographs by Stephen H. Seckner, a Fort Collins photographer. These are two of his images, the upper one showing the ditch in a serene environment and the lower image showing a section of the wooden flume that takes the water down a steep incline. (Right, FCLHA H07714; below, FCLHA H07697.)

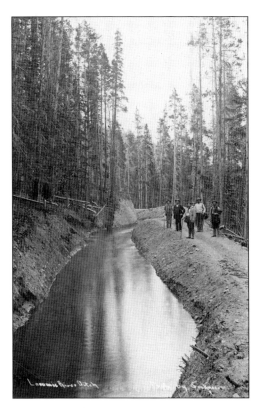

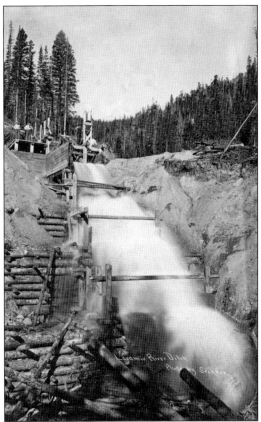

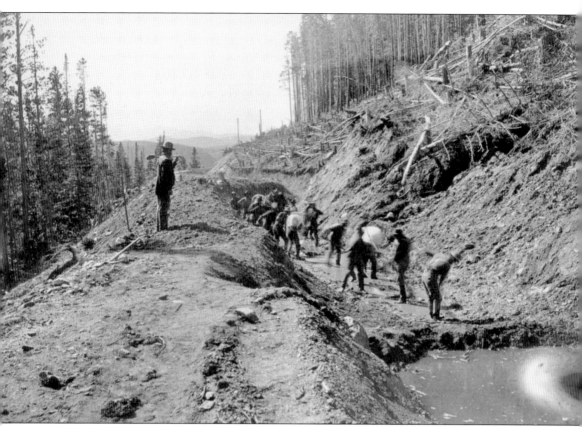

Digging the Grand Ditch was hard work, as this photograph shows; the laborers were primarily Japanese and Mexican immigrants who were paid 22.5¢ per hour and charged 25¢ for each meal. The workers were housed near the worksite. Historic accounts give the initial flow of the ditch, which diverted water from the Grand River, as occurring in 1890. Considered an engineering marvel at the time, the ditch allowed water, which was inclined to flow west, to instead flow east into Long Draw Reservoir. At first called the Grand River Ditch, the diversion was renamed the Grand Ditch when the Grand River became the Colorado River in 1921. In 1935, when the ditch was lengthened and upgraded, Case describes workers with jackhammers, suspended from ropes, drilling holes for dynamite. (FCLHA H07700.)

Nine

NORTH AND SOUTH FORKS OF THE POUDRE

A number of streams and creeks feed into the Poudre River, but the two main tributaries are the North Fork and South Fork, also called the Little South Fork.

Fed by numerous streams and tributaries, the North Fork of the Poudre River starts near Deadman Hill (the reason for the name is obscure), elevation a little over 10,000 feet, and tumbles nearly 60 miles down through Cherokee Park, passes Frank Miller's long-gone Trail's End ranch, goes through Phantom Canyon, comes near the Forks Hotel, and at an elevation of around 5,000 feet, empties into the main body of water below Gateway Park, formerly the city waterworks.

The South Fork, a much shorter river, begins in the Mummy Range in Rocky Mountain National Park, goes through Pingree Park, and enters the river near Dutch George campground. A portion of the South Fork is designated the Cache la Poudre Wilderness, described by one author as a pristine area difficult to access and in one newspaper article as "the true wilderness portion of the river." The South Fork is considered prime territory for fishermen, who must walk or ride horses to get to the best areas. Few sections of the fork are reachable by automobile. This chapter stops by the Halligan Dam, one of several dams and reservoirs that capture the river's water, visits Cherokee Park, looks at a typical CCC camp, and ends at Colorado State University's Pingree Park.

Poudre Canyon resorts used ice from the Poudre River to stock their icehouses. Pictured here around 1925 is a group of men cutting ice on the gentler North Fork, probably for their farms or ranches. The Fisk property, mentioned in the Early Roads chapter, is in the background. (FCLHA H11378.)

The Eaton, Milton Seaman, and Halligan Reservoirs store water along the North Fork of the Poudre. The Halligan Reservoir, shown here, was the first and largest of the three reservoirs. Completed in 1910, the dam is 339 feet long and 85 feet high. Harlan Seaworth, president of the Northern Poudre Irrigation Company, is shown in this 1985 photograph. (FCLHA H13124.)

Just why William and Phoebe Campton came to the Fort Collins area with their six children is not known, but come they did in 1886. By 1891, they were homesteading a ranch at Cherokee Park, and in 1895, a large house, newly built after a fire, was ready to receive guests at the Cherokee Park Dude Ranch—a "dude" being an Easterner unschooled in Western ways. (FCLHA H02048c.)

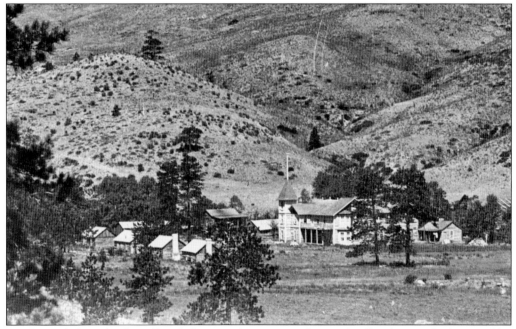

Cozily nestled among the rolling hills west of Livermore, the ranch offered guests fresh vegetables and fruits from the garden, fresh milk, butter, and cheese from the dairy herd, and "curative" water from a bubbling spring nearby. Guests came from as far as the East Coast to enjoy the Camptons' hospitality and hunt, fish, ride horses, or hike—for, in 1901, $1.50 per day. (FCLHA H05436.)

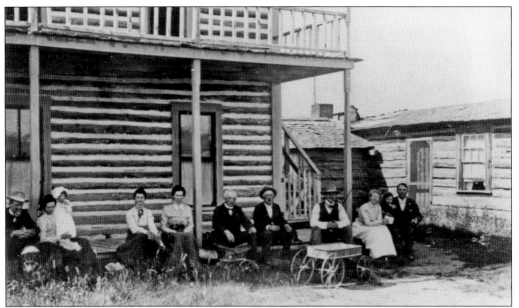

Newspaper editor Ansel Watrous, for whom a Poudre River campground is named, enjoyed coming to Cherokee Park. In this photograph, he sits exactly in the middle, probably on the porch of the main house. The Camptons had some wild animals on the premises, and a number of Native American artifacts have been discovered on the land, some of which were on display in their home. (FCLHA H05439.)

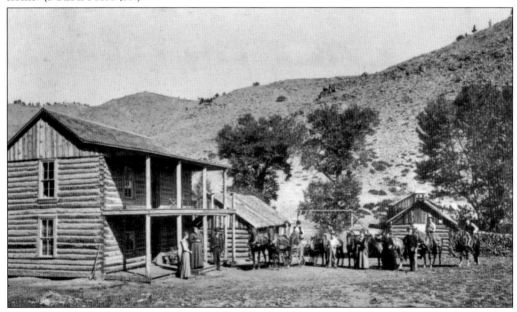

This photograph shows the main resort building, with some cabins at right. Horseback riders appear to be preparing for a summer's-day ride into the foothills beyond. After the Campton parents retired, their daughter Louise and her husband, Jack Bell, operated the guest ranch until the Depression made it too difficult. Several changes in ownership followed. Cherokee Park is still an active guest ranch, offering time-honored activities coupled with modern amenities. (FCLHA H10921.)

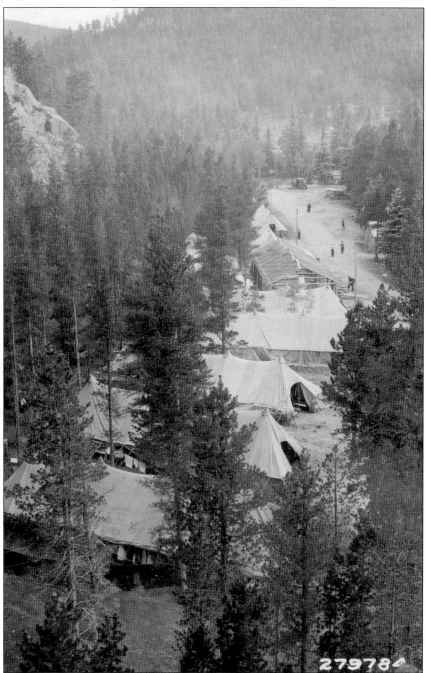

Like other CCC camps, this one featured barracks-type housing for the men who worked at the camp. Established on the South Fork, the camp sat amid a flat forested area, just south of today's Fish Creek Picnic Area (on Pingree Park Road, 9.2 miles from Colorado 14). This camp was designated F-2, where the F indicated a camp in a national forest, and was established on January 15, 1933. The camps were set up to provide workers for a variety of conservation projects; it is unknown what the workers here were assigned to do, but whatever it was, they left the landscape better for their presence. (USFS.)

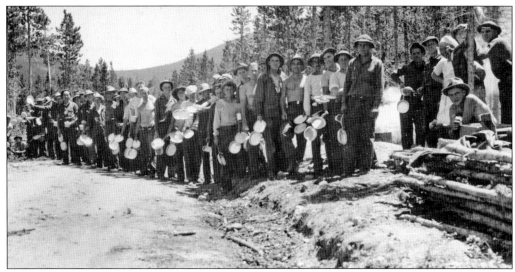

The government housed and fed CCC workers, and the meals were more substantial than they probably would have had otherwise. Here, a group of workers lines up for chow, tin plates in hand. State relief agencies screened enrollees for the program, with acceptance determined by the degree of hardship the applicant's family was suffering. Among other projects, CCC laborers worked on soil conservation and flood control. (USFS.)

Just like in the Army, some CCC residents were put to work peeling potatoes. Here, several men work at the task. Potatoes were no doubt a staple of the campers' diets. Along with other benefits, the men received some education and free medical care, a bonus during the Depression years. It has been said that time spent at a CCC camp offered the perfect preparation for military life during World War II. (USFS.)

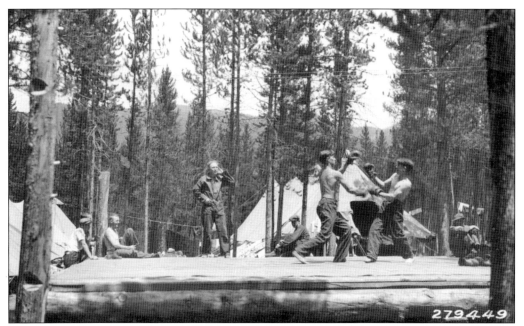

Life was not all work and no play. The men took part in sports—here, they are boxing, freestyle. They also formed baseball teams (lacking the protective equipment available today) and took part in various other sports activities. With what remained of their pay after the majority had been sent home to their families, they could purchase small items like cigarettes. (USFS.)

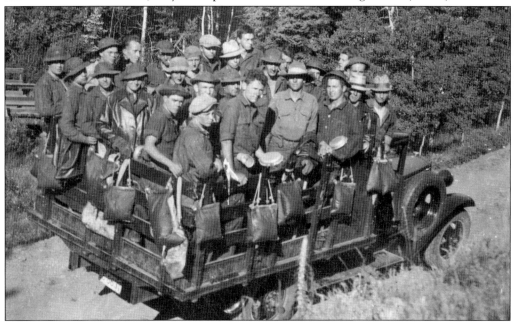

Enrollees hang on as a truck moves them from one site to another. Toughened by the hard work outdoors in the higher altitude, they still might have appreciated having transportation so they would not have to walk. Along with other projects, workers at the Little South Fork CCC camp constructed a road for access to the area. The road led from the South Fork junction to Bennett Creek, northwest of the tributary. (USFS.)

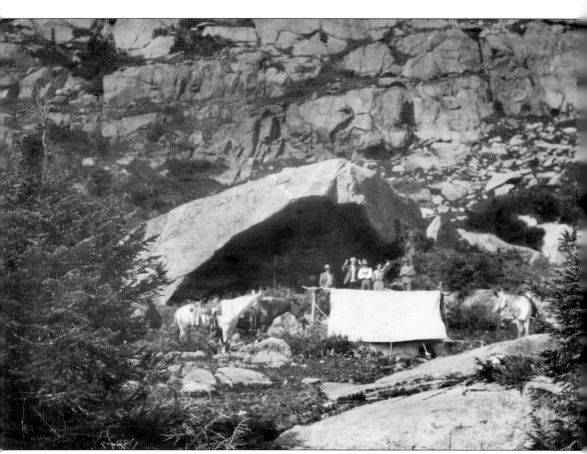

In 1912, an act of Congress gave 1,600 acres of Colorado National Forest land to the college. After deliberations with state officials, the school decided to take the land all in one location. Forest supervisor H.N. Wheeler suggested a location where George Pingree had headed a tie-cutting gang. In August 1914, Wheeler, along with Gov. E.M. Ammons, college president Charles A. Lory, Prof. Burton O. Longyear, and Pres. E.E. Edwards of the State Board of Agriculture made the two-day trip to inspect the site. This is an image of their campsite near the future Pingree Park; the figures are too small to identify by name. (FCLHA COMT2-84.)

A lodge was quickly built on the land, soon becoming the center of the campus. Completed in the fall of 1914, the lodge hosted a civil-engineering class in 1915 and the first forestry class, taught by Professor Longyear for one student, in 1917. The photograph above shows the lodge, around 1924. The mountain campus slowly expanded, adding a bunkhouse in 1927 and these student cabins, copied from the Biltmore Forest School in North Carolina, probably built by the WPA in the 1930s. (Above, FCLHA 16437; below, University Historic Photograph Collection, Colorado State University, Archives and Special Collections.)

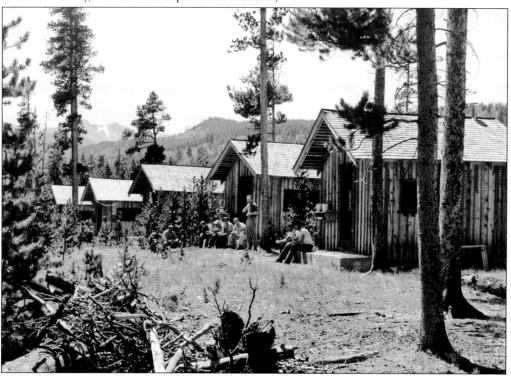

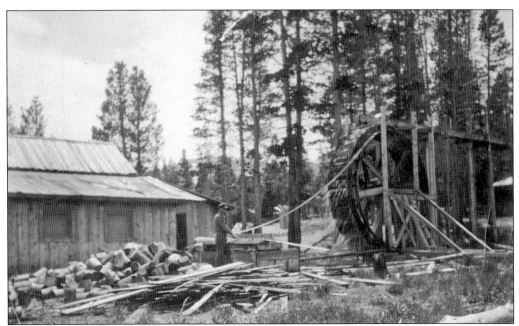

Some of the wood used for the mountain campus buildings was probably supplied by Hugh Ramsey's sawmill. Ramsey homesteaded an early site in the Pingree Park area. By 1898, he had completed a house and barn. and his family had moved in. He soon started a sawmill with a water-powered wheel, shown in this photograph from around 1924. (FCLHA H16428.)

In August 1925, the small Pingree Park School opened, mostly for the children of homesteaders Frank and Hazel Koenig. This image shows the five Koenig children in no particular order: King, Oren, Angela, Joyce, and Dorothy. Because of the weather at 9,000 feet, the school ran a summer schedule from June until snow made travel impossible. The building is still intact on the CSU campus. (FCLHA H01201.)

Housed in the Fort Collins Museum of Discovery, 408 Mason Court, the Fort Collins Local History Archive preserves artifacts, photographs, books, and documents that tell the story of Fort Collins and Larimer County and shares their historical riches with researchers, authors, genealogists, students, and other interested individuals. For local history questions or collections to donate, contact the archive at 970-221-6688 or look online at history.fcgov.com. (FCLHA.)

Discover Thousands of Local History Books
Featuring Millions of Vintage Images

Arcadia Publishing, the leading local history publisher in the United States, is committed to making history accessible and meaningful through publishing books that celebrate and preserve the heritage of America's people and places.

Find more books like this at
www.arcadiapublishing.com

Search for your hometown history, your old stomping grounds, and even your favorite sports team.

Consistent with our mission to preserve history on a local level, this book was printed in South Carolina on American-made paper and manufactured entirely in the United States. Products carrying the accredited Forest Stewardship Council (FSC) label are printed on 100 percent FSC-certified paper.